Fundamentals of Egg Tempera
Painting

**An Exploration of Traditional Painting
Techniques Using Egg Tempera**

Ed Valdes

To My Wife and Son,
Whose Love Has Always Been and Inspiration

Fundamentals of Egg Tempera Painting
An Exploration of Traditional Painting Techniques Using Egg Tempera

Copyright © 2023 by Ed Valdes

Published in the United State of America

ISBN Hardback: 979-8-9887870-0-6
ISBN Paperback: 979-8-9887870-1-3
ISBN eBook: 979-8-9887870-2-0

Book Cover and Interior Design: Creative Publishing Book Design

Front Cover:
The Loxahatchee River, Florida
Plein Air Painting. Egg Tempera on Bainbridge Board Primed with Chalk Ground. 5"x7".

Contents

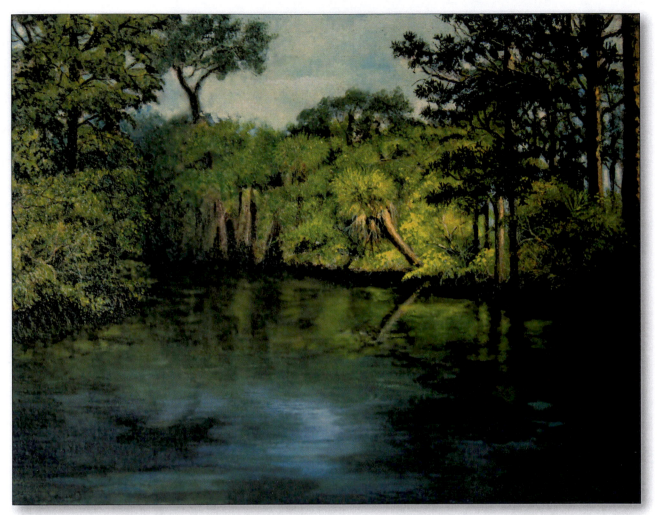

The Loxahatchee River. Plein Air painting. Egg Tempera on Bainbridge Board primed with chalk ground, 5"x7".

Introduction

This book teaches general egg tempera techniques. Topics discussed include the yolk water emulsion, grassa, the mixed technique, applying gesso, and assembling supports. It illustrates the use of egg tempera for representational painting and ways to think visually. Specifically, it examines three major concepts and practices: Classicism, Naturalism, and Realism. The emphasis is on egg tempera's potential as a painting medium. The traditional Renaissance methods are the foundation of the procedures. Still, the practices and concepts described in this text are ultimately my interpretations and reflect a naturalist bias. Therefore, I've included only examples of my work.

Mastery of egg tempera is achieved by painting. After you learn the basics of the medium, make progress by practicing to create a picture that looks and expresses your visual goal. Few books were available when I began painting in egg tempera in the mid-1990s, and little to no one was teaching it.

Today, there are many opportunities to learn and ample information. I encourage readers to expand beyond this text, examine other books on egg tempera, and seek hands-on instruction.

The book consists of two parts. Part one is egg tempera techniques. Part two discusses my understanding of universal representational painting strategies using egg tempera as the medium. I have included demonstrations of paintings by observation and indirectly by reference, supplemented with relevant historical and aesthetic comments.

The bold italic words throughout the book highlight important concepts or are essential terms explained in the glossary.

Egg tempera painting is ancient but hasn't reached its full potential as a painting medium. Eclipsed over 300 years by oil paint, painters haven't explored it entirely. This book has succeeded if it encourages artists to investigate this fascinating medium.

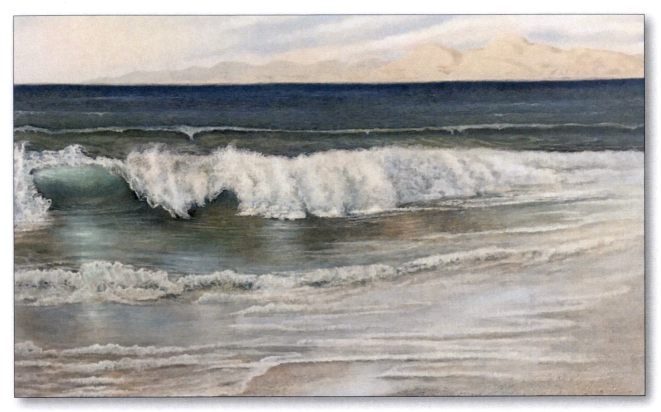

Shore of Light. Studio painting, Egg Tempera on Harboard primed with chalk ground, 8" x 12".

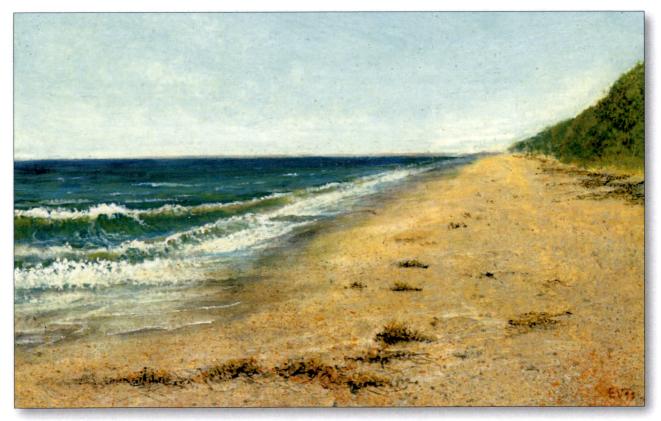

Jonathan Dickinson's Beach Park, Florida. Plein Air Painting. Egg Tempera on Bainbridge board primed with chalk ground, 5"x7".

PART 1

The Craft and Materials of Egg Tempera Painting

Why Paint with Egg Tempera

Oil is the paramount medium of the representational painter, and with good reasons. It's a flexible, helpful medium for any aesthetic goal- but slow drying, cumbersome for textures.

There's a unique competitive rival, Egg Tempera.

Egg tempera is a medium capable of achieving virtually any effect. Alone or combined with oil, it's potentially a vital alternative to oil painting. It has certain advantages over oil:

1) It's clean and efficiently transported.
2) The paint film dries fast; new paint layers don't lift the prior one, which helps to achieve optimal color effects and small details quickly.
3) It is superbly archival and permanent without the danger of surface cracking in time.
4) Adding new **layers** makes the paint quality increasingly beautiful.
5) It excels in accurately representing any texture.
6) Its paint film can be made to look **transparent, translucent, or opaque,** quickly enabling maximum control of the character of the paint layer.
7) It can mix with a **drying oil,** extending its capabilities.
8) One can easily experiment, and the paint can be applied using a variety of brushes and tools.
9) Except for the initial purchase of pigments, it is inexpensive to use.
10) Egg tempera is predominantly **linear,** but it's possible to use **painterly**.

This list describes a very adaptable multifunction paint, one of the oldest and most practical mediums ever invented.

Egg tempera is ancient. There's evidence of an egg binder in 20,000-year-old cave paintings.[1] It likely was used throughout Anatolian, Asian, Egyptian, and Greco-Roman civilizations.

Egg tempera paint is made by adding fine-colored particles, called pigments, to the yolk of an egg mixed with water. The egg yolk and water mixture is called a yolk-water **emulsion**.[2] The yolk itself is a natural oil (triglycerides) in water liquid emulsion.[3] A liquid emulsion is a dispersal of tiny insoluble droplets of one liquid in another. In the oil-yolk emulsion, egg oil disperses in the water. Lecithin and protein in the yolk act as emulsifiers, keeping the components from merging and separating. This combination is what gives egg tempera its unique qualities.

The yolk emulsion, and the added water, combined with the pigment particles it binds, become the paint. In the yolk emulsion, water is the liquid aspect of the emulsion, which helps keep the triglycerides and proteins in the yolk from coagulating. Together, the yolk emulsion, with any additional water added, constitutes the medium. Since water dissolves the yolk, egg tempera is a water medium. Still, its properties are very different from watercolor, gouache, or acrylic paint, which also uses water as the solvent. Egg tempera has a unique and indescribable character. But because yolk has oil components made of triglycerides, and depending on use, egg tempera paint can behave like a very fast-drying thin oil paint.

There are objections to this medium, and many naturalist painters find these disadvantages:

1) The medium is commercially unavailable. The yolk-water emulsion is home-made, and it spoils quickly.

2) Although the paint will stick to practically every surface commercially available (clay-board, all sorts of acrylic grounds, paper, etc.), it works best on **chalk ground.** Chalk is a fine white, plaster-like powder mixed with **animal glue** or **gelatin**; the mixture is called **gesso**. It covers strong supports such as wood, dries to a rough plaster-like harness, and sands to a silky smooth finish. An acceptable commercially available gesso, Rublev Tempera Ground, is a functional alternative to real gesso, albeit not as absorbent.

3) Egg tempera dries very fast and must not be redissolved. The fast **working time** allows immediate layering, developing details and textures, and working very precisely, but prevents the paint from being physically blended like oil paint. Redissolving the layer lifts it off the surface.

4) The paint film cannot continuously be applied in wet, thick layers. A small raised paint layer is possible. But thick wet immediate impastos are impossible. Thick wet paint will crack.

5) Dark saturated colors, standard in oil, may look lighter in value and cooler in hue. The yolk water emulsion has a lower **refractive index** than oil. This index measures how much a material bends light.[4] Colors in mediums with a lower score tend to appear lighter.[5]

6) The working process is inherently methodical. An experimental, spontaneous approach is possible but it's a problematic strategy. As the painting develops, the process slows and may seem demandingly laborious. This exertion is genuine regardless of the approach or **aesthetic** goal of the work. The methods of egg tempera arise from the inherent characteristics of the yolk-water emulsion, which impose an intrinsic discipline on the painter. These characteristics are the fast-drying nature, the paint film's transparency, the paint's fracturing in flexible support, and the need to build up the painting gradually in thin layers to prevent it from cracking. As a result, the pace of tempera painting tends to be more deliberate and slower than other fluid media.

7) Pigment handling is harmful if inhaled or swallowed. Wearing masks and gloves is a prudent precaution to prevent toxic exposure.

8) Painting with egg tempera has a long learning curve compared to the other mediums. Your first egg tempera paintings will likely not appear as you intended. You must be patient in learning how to manipulate the paint. If you make your gesso panels, it will increase the learning curve time and challenge.

9) Although works of large dimensions are possible, egg tempera paintings are painted faster when making small pictures.

Many objections often result from a lack of mastery and, with time, as skill increases, are not significantly worse than with the limitations of other mediums. Egg tempera is an excellent medium for **naturalism**.

Except for effects that require high impastos, and extremely dark saturated colors, egg tempera is capable of all **illusionistic** intentions. Many effects are frequently better and made faster than with oil paint. This benefit is especially true when rendering textures and details. The atmospheric and the softly blended surfaces, easily achieved with oil paint, take more elaborate skills to accomplish, but they are definitively possible.

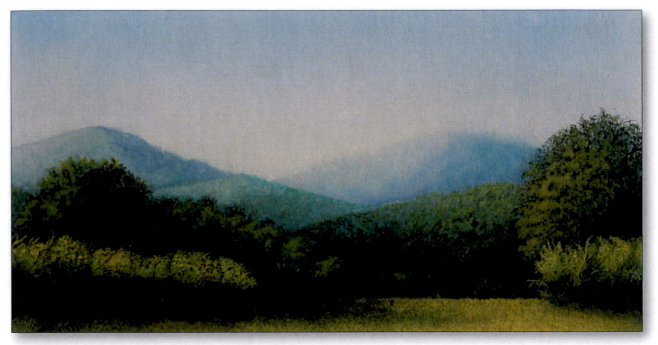

Tranquility – Shenandoah National Park. Studio painting. Egg Tempera on Hardboard panel primed with chalk ground. 4.5"x7".

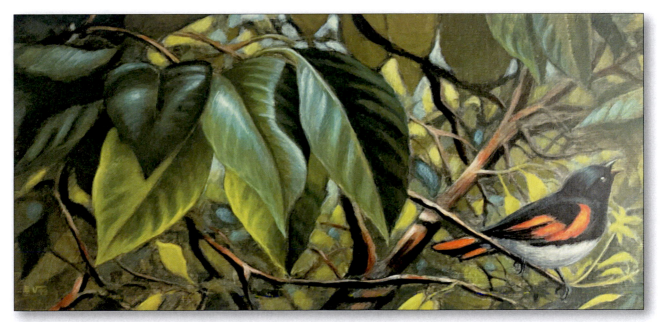

Redstart. Studio painting. Egg Tempera on Bainbridge board primed with chalk gesso 5" X 12".

There's no better way to learn how nature appears to us than directly drawing and painting from life. Egg tempera painting from life is more challenging than with watercolor, gouache, oil, or acrylic, readily available tube paint. Their paint film is also faster to manipulate. But if you can overcome the difficulties, I believe egg tempera is better than other water-soluble mediums to depict reality.

The Yolk-Water Emulsion

Buying authentic egg tempera in an art store is impossible since it would rot in its container within several days. Several companies make egg tempera tube paint. These paints are not legitimate egg tempera, contain oils and preservatives, and do not behave like egg tempera. They are yolk-oil emulsions. Furthermore, these emulsions are different from homemade yolk-oil emulsions (called **Grassa**). To make the Yolk-Water Emulsion assemble the following supplies:

- Several fresh chicken eggs. The brand and size don't matter, but be sure they are not old eggs beyond the expiration date (the yolk sack tends to tear in old eggs).
- Clean water. Distilled water is said to be best.
- One large bowl
- Two small drinking glasses with a narrow top
- One small jar with a lid
- Paper towels
- A pointed knife
- Cheese cloth or small sieve
- Optional: white vinegar and eye dropper

The following sequence of photographs illustrates making the yolk-water emulsion.

The first step is to separate the yolk from the egg white. We do not want albumen combined with the yolk; it makes the paint dry faster. The second step in the process prepares the yolk-water emulsion.

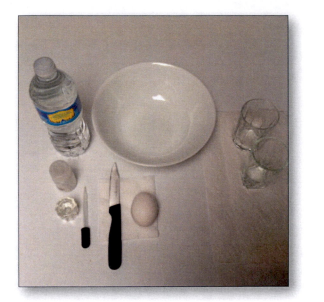 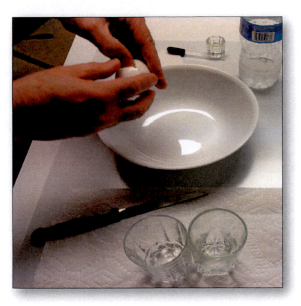

Set up to make the yolk-water emulsion. Clockwise: clean water, a large bowl, two small glasses, two paper towels, a fresh egg, cheesecloth, a pointed knife, one jar with a lid, one small container, and an eye dropper. The small container to hold vinegar. The dropper place drops of vinegar as a preservative.

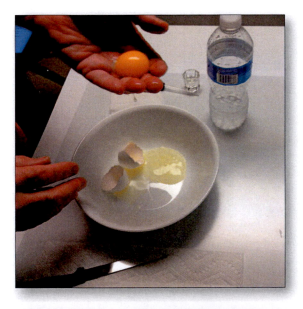 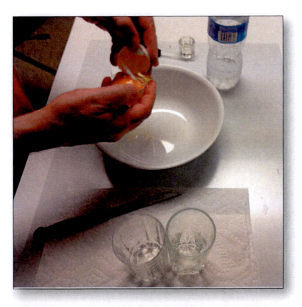

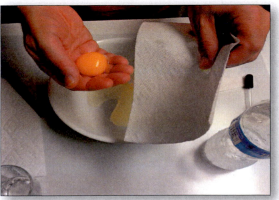 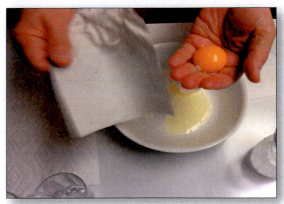

Separating the yolk sack

Open the egg and pour its content onto the palm of one hand. Let the egg white fall through your fingers and into the large bowl. Roll the egg yolk from the palm of one hand to the next. Let one hand hold the yolk, and clean the other hand with one paper towel. You will notice the yolk will become dry. Pick up the yolk by the yolk sack with your index finger and thumb of one hand. Hold the knife with your other hand. Hold the yolk over a glass. Puncture the yolk sack with the knife. The yolk will fall into the small glass. Trash the yolk sack.

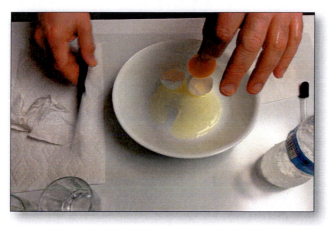

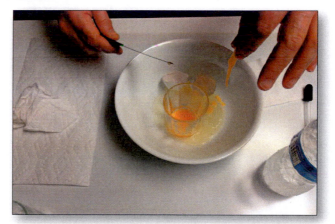

Preparing the yolk-water emulsion:

Adapt a piece of cheesecloth (or a small sieve) on the rim of the second small glass.

Pour a small amount of water into the first small glass with the yolk content. The amount of water preferred is personal. It depends on how dense you want the medium. I place about a fourth of the yolk content. A dense medium will feel more like a fast-drying oil paint. A diluted medium will lack density or body, and the paint will feel more like watercolor.

Use the knife to mix the yolk and water thoroughly to create the yolk-water emulsion.

Pour the content of glass one through the cheesecloth into the second glass to filter any white residues in the emulsion.

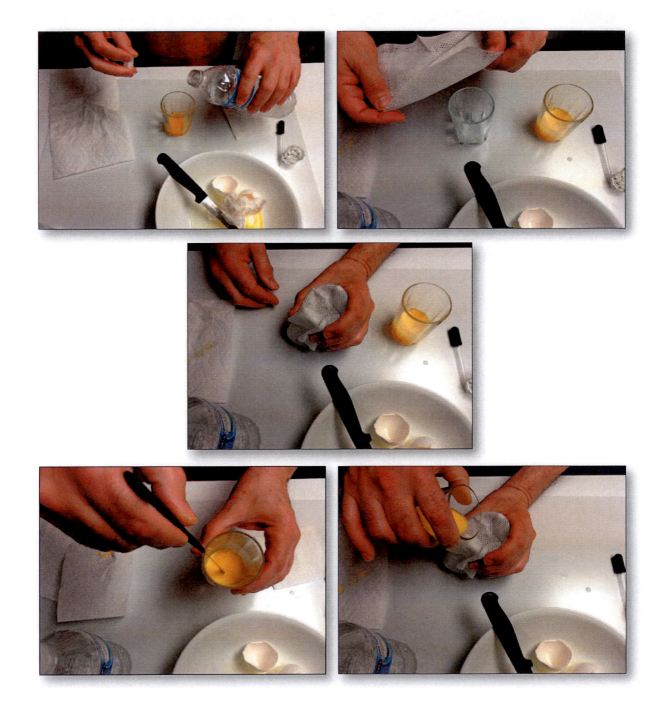

Place the yolk-water emulsion into a container with a lid.

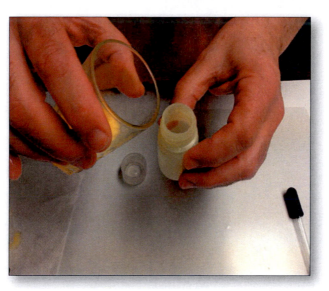

When painting plein air, add 2 to 3 drops of white vinegar into the emulsion as a preservative. The medium will remain fresh longer before a sulfur smell indicates that putrefaction has commenced. With refrigeration, the medium can last fresh for about four days. The vinegar is optional. Many tempera painters feel that certain pigments, specifically ultramarine, react negatively to the content. I have never seen this happen.

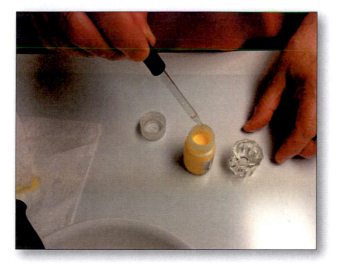

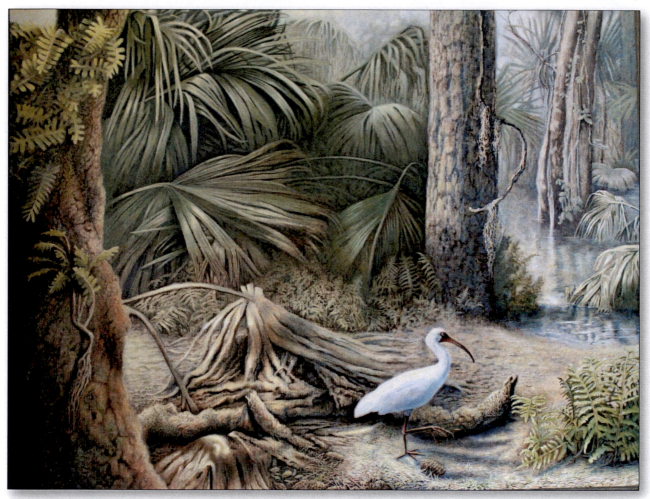

The Seeker of Wisdom. Studio painting. Egg Tempera on Bainbridge board primed with Rublev ground, 16″ x 20″.

The Yolk-Oil Emulsion - Tempera Grassa

Yolk- oil emulsions, collectively known as tempera grassa, modify the traditional egg tempera medium by adding a drying oil and frequently supplemented with a **resin**- or **alkyd** -to the yolk-water emulsion. I want to stress that the yolk-water emulsion is sufficient by itself and does not need any additions to create natural effects.

Egg tempera's beautiful properties diminish by adding excess components to yolk-water emulsion. Furthermore, these emulsions can be unstable-the elements will separate-inducing an archival issue. So why do some egg tempera artists add oil and resin? For the same reason, oil painters add resin varnishes, balsams, dryers or retardants, opaquer, and other components. Watercolor artists add glaze mediums, ox gall, wetting mediums, and others. Acrylic painters frequently add retardants, glaze mediums, etc. They add these to modify- or add to the characteristics of the medium. These additions do not change the fundamental nature of oil painting, watercolor, or acrylic; the same is valid for egg tempera. Adding oil to the yolk-water emulsion shouldn't change egg tempera to a new medium. Of course, one can add quantities of oils that overpower the water-soluble yolk-water emulsion. If so, the paint will no longer behave like egg tempera. It will become more like oil paint with a drying agent- the emulsion will induce the oil to dry much faster than pure oil paint. It will no longer be soluble in water. Referred to as oil-yolk instead of yolk-oil emulsion, I don't consider it egg tempera. Successful additions to the yolk-water emulsion, at least for my preference, have three qualifications:

1) The solvent is water.
2) They are physically stable.
3) They specifically modify a water- yolk emulsion characteristic.

The successful addition of a small amount of drying oil will strengthen the paint film, increasing the ability to apply a thicker layer. A varnish–such as damar varnish or an alkyd medium combined with the yolk-oil emulsion-will help use a more evenly thicker **glaze**. Contrary to intuition, the extra oil does not increase the working time. The paint dries at about the same time as the yolk-water emulsion. I have found a way to increase the operating time slightly, but not by adding oil, and I will describe it later in the text. One can change an important characteristic, the reflective index, by adding varnish or alkyd to the oil-yolk emulsion. The varnish raises it, and the colors will look more saturated. With only oil, the reflective index will remain about the same as with yolk-water emulsion, and the color of the dry film will look very similar to regular egg tempera.

It's helpful to consider when and how to use the emulsion in the painting process. Is the yolk-oil emulsion intended to be the only medium used for the painting? Or will it be used selectively to supplement the yolk-water emulsion at a specific place in the picture for one particular effect? This foresight helps to minimize or prevent time-consuming significant corrections.

Making grasa:

I have experimented with many emulsion recipes. These, found in various books published in the last century, have slightly different effects on the yolk-water emulsion. I've expanded beyond these recipes and created my own. Among the many I made, I've settled on one and occasionally use it. I've included books that address emulsions in the bibliography for the interested reader.

The yolk-oil-surfactant emulsion, YOSE-is intended to achieve the following:
1) Water solubility
2) The components permit the assimilation of the yolk-water layer with the yolk-oil layer.
3) Permits a thicker paint film.
4) Enables slight physical blending.

I use YOSE to supplement the yolk-water emulsion at specific places in the picture when wanting a very oil-like smooth transition, to increase the thickness of highlights, and when I want an extensive painterly effect. YOSE emulsion doesn't change the refractive index. The paint film resembles the yolk-water emulsion. I rarely use it in isolation as the only medium and apply it only if needed to complete an effect.

To make YOSE assemble the following supplies:

- one egg
- water
- Winsor & Newton Artisan water mixable linseed oil.
- Winsor & Newton watercolor blending medium.
- small dish
- 1/8 teaspoon. Stirring rod.

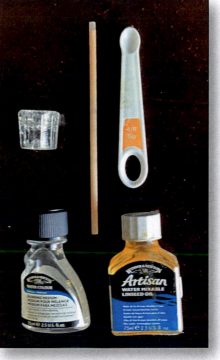

I have no connection with Winsor & Newton. It's what I use, but other water-mixable oils could work. The point is that the oil is solvable by water just as the yolk- water emulsion. It allows the upper yolk-oil paint layers to assimilate with the lower yolk-water layer, creating a solid bond. The lower yolk-water layer doesn't lift when applying the yolk-oil layer.

As I've written, adding a small amount of oil doesn't prevent the yolk-water emulsion from drying quickly to allow blending. If physical blending is a goal, wetting agents- surfactants- instead of adding more oil- are needed to enhance the blending properties and create a more fluid and even application. A is **surfactant** reduces the surface tension of water, allowing it to spread more rapidly and evenly across a surface.[6] The wetting agent can help the paint blend more smoothly and evenly. However, even with a wetting agent, the emulsion will stay wet just enough to

permit slight physical blending. Like with a yolk-water emulsion, the yolk-oil-surfactant emulsion, once dry, should not be re-dissolved.

Pure glycerin, gum Arabic, Ox Gall, Propylene Glycol, and Winsor & Newton watercolor blending medium are four readily available wetting agents; there are others. The most workable of these is Winsor & Newton product (exact components are trade protected. It is said to contain Propylne Glycol, Gum Arabic, water, and an undisclosed acid).[7] Propylene Glycol (available from Earthborne Elements at Amazon) also works well, but the amount added to the emulsion must be minimal. It can quickly become excessive and prevents the paint from drying. Accidentally, adding a wetting agent to only the yolk-water emulsion extends the working time but excessively thins the paint. I don't recommend it.

The following are the proportions of the YOSE components. Vigorous stirring is required to achieve an integrated emulsion. Stir each time before use.
- 1 part yolk-water emulsion
- 1/2 part water mixable oil
- 1/8 part weting agent- surfactant (W&N product, Glycerin, Gum Arabic, Propylene Glycol)

I only mix small amounts, and I prepare the emulsion only for the painting session needed.

The 1/8 teaspoon measures the parts of each component.
- 1/2 tsp yolk-water emulsion
- 1/4 tsp water mixable oil
- 1/8 tsp W & N watercolor blending medium

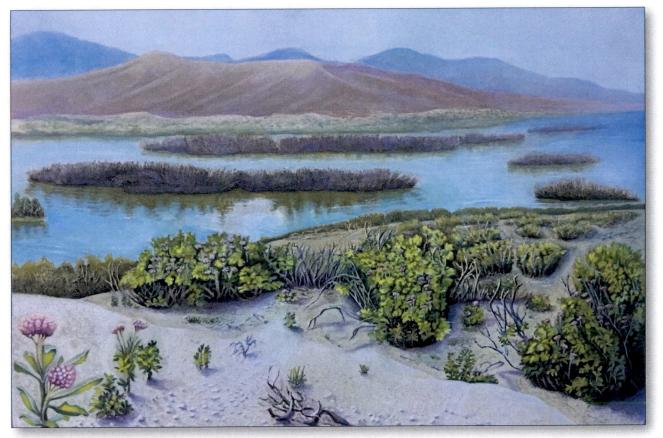

Wetland from the Chilean Coast. Studio painting. Egg Tempera and Yolk-Oil Emulsion-Grassa on Hardboard primed with chalk ground, 8" x12".

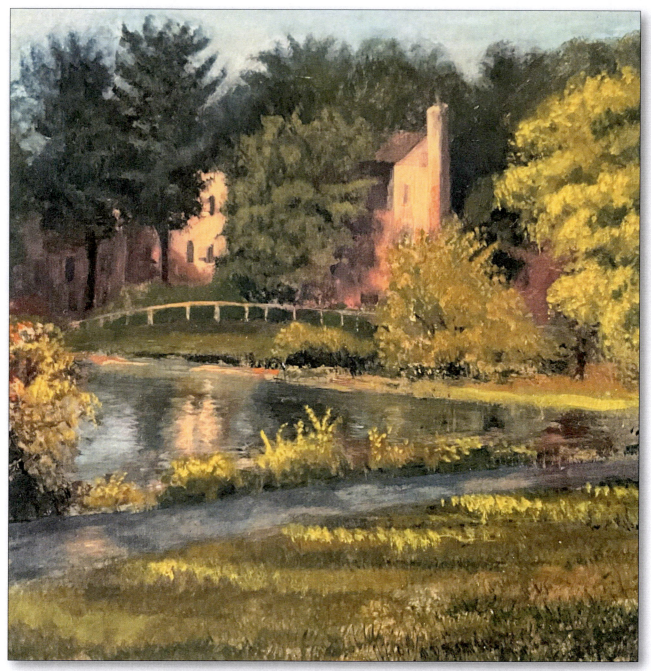

Lake Side. Plain Air painting. Yolk-Oil Emulsion-Grassa on Hardboard primed with chalk ground, 8″ x 10″.

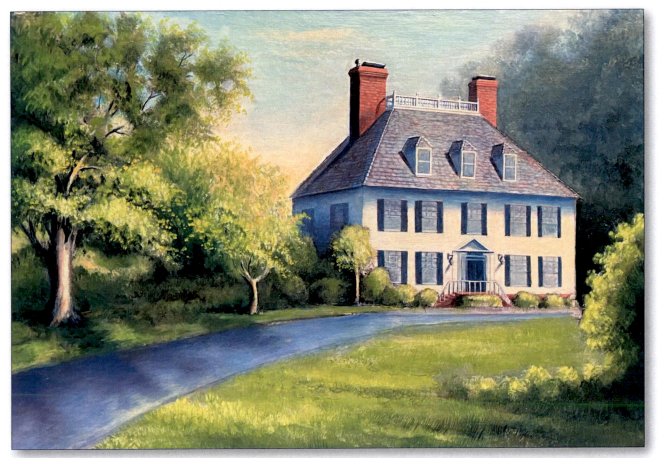

Virginia Home. Studio painting. Yolk-Oil Emulsion- Grassa on Harwood rimed with chalk ground, 8″ X 12″.

Florida Canal. Plein Air painting. Egg Tempera and Oil on Hardboard panel primed with chalk ground. Mixed Technique, 5"x7".

The Mixed Technique

In 1921 professor Max Doerner published a monumental book on Painting: "The Materials of the Artist, and their use in Painting, with Notes on the Techniques of the Old Masters." [8]The book content resulted from formal academic investigations by Doerner at the Royal Bavarian Academy. Doerner assumed a professorship in 1911 (Doerner,1921). On page 327 of the book, he describes a painting process that he believed to be the Technique of Van Eyck and the old German masters. He called it the **mixed technique** (Doerner, 1921). Contemporary chemical and spectral investigations of these early northern renaissance paintings have disproved the mixed technique as the early Nenderladish method (Streeton, 2013)[9]. However, be that as it may, the technique results in pictures that resemble the Flemish painting aesthetics, with its microscopic details, the perfection of form, and brilliant color. After Doerner published the book, many artists adopted the method, notably Ernst Fuchs.

The method consists of drawing with prepared yolk-oil emulsion or simply with the yolk-water emulsion paint, using a small round brush, into a thinly applied resinous oil coating or oil glaze. The emulsion, soluble in water, does not mix with the oil glaze. The water and oil cannot incorporate. The color used to draw is usually opaque white, or yellow. The **tempera inlay** dries within seconds, and applying a new color oil glaze over the drawing is possible.

The process repeats. The final results can look like a northern renaissance artist had painted it. I used this mixed technique to create the Florida Canal.

A characteristic of this technique is thin, drawn lines. Notice the thin lines in the painting that represent palm leaves. Egg tempera details this miniature painting by embedding tempera into a resinous oil paint mixture. Glazed with oil are deep shadows and various hues of green. The egg tempera and oil form a playful alternation. I was drawing with tempera and coloring with oil. The painting, created from life, took about 8 hours. I couldn't complete the detail painting this quickly without the interaction of egg tempera and oil paint. The results fascinated me.The paintings The Florida Canal and the Edge of the Forest (shown below) are old works made in 1998. One can ask if the complex layers of oil and tempera are archival or will one day break down and separate. I don't know. But for 25 years, the paintings remain intact.

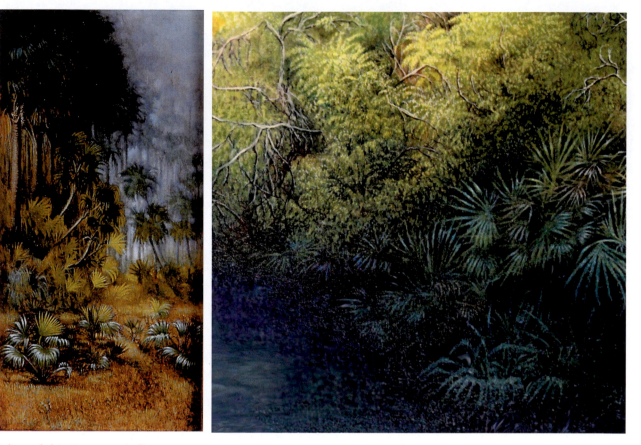

Edge of the Forest, Studio painting. Egg Tempera and Oil on hardboard primed with chalk ground, Mixed Technique, 3" x 6".

Plants Near the River. Plein Air painting. Tempera and Oil on hardboard primed with chalk ground. Mixed Technique, 8" X 9".

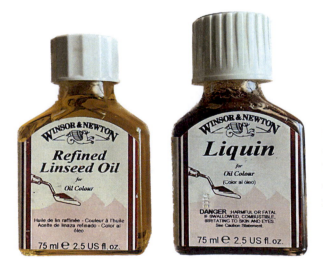

Mix the alkyd Liquin with linseed oil to create the resinous oil glaze for drawing into with the egg-yolk emulsion and to glaze over the tempera- inlay.

Gesso and Supports

The Chalk Ground

A rigid surface primed with gesso is the standard surface for egg tempera painting. I have tried other grounds. The tempera sticks, but not with the same tenacity as the traditional gesso ground. **Acrylic gesso** is not the same. Even though acrylic gesso has similar mineral components as chalk gesso, its binder is a synthetic plastic polymer. Unlike the hydrophilic gelatin or animal glue-based gesso, the yolk-water emulsion chemically fails to absorb into the water-repellent surface of the acrylic gesso. The result is that as the layer of the paint build-up, it can eventually slough off due to the lack of adherence.

The mineral component of chalk gesso is **calcium carbonate** mixed today with a bit of titanium white. Except for the titanium white, this material was the ground used in Northern Europe. Marble dust was, and is still, added today to lighten the value. Titanium white has replaced the lead white used in the past. In the south of Europe, in Renaissance Italy, instead of calcium carbonate, magnesium carbonate is used and is called gesso from Bologna, rarely used today.

Gesso making remains unchanged over many centuries. No one knows who first made gesso. Cennino d'Andrea Cennini's classic text "I'll Libro dell Arte," written in 15th century Florence, remains the primary source for preparing it for panel painting.

For my formulations for making gesso, I use the Daniel Thomson's book "The Art and Craft of Egg Tempera Painting"[10] and Altoon Sultan's book "The Luminous Brush."[11]

Thomson and Sultan mention gelatin to make the glue or size, and there's controversy about using the weaker gelatin. Gelatin is from an animal source. Animal glue is also an animal collagen product, a more robust and preferred material, and many artists and conservators recommend using only animal glue. However, I've used gelatin and animal glue, but I haven't found a difference in the quality of the gesso. They look similar, and both are equally absorbent. Be that as it may, the procedures for making gesso are the same, either animal glue or gelatin.

Making the Chalk Gesso

Making traditional chalk gesso is not complicated but time-consuming. There are five essential requirements for success:

1) You must measure the components as carefully as possible.
2) You must apply the layers of gesso to the panel gently.
3) Do not not work in damp cold weather.
4) You must carefully assemble the recommended supplies.
5) Do not overheat the gesso.

The two following ratios should be committed to memory:

Fundamental ratios 1: 16 and 1: 1.5

The ratio 1:16 is the standard proportion for animal substance and the water. It will work for either gelatin or animal glue. The glue-like mixture is called size.

The 1:1.5 is the standard proportion for the size and the chalk.

FUNDAMENTAL SIZE FORMULA

1 part gelatin or animal glue to 16 parts water = size

FUNDAMENTAL GESSO FORMULA

1 part size to 1.5 chalk = gesso

The amount of gesso you will need depends on the number of panels and their dimensions. Divide or multiply the fundamental formulas to make less or more gesso amounts, respectively. I have made 6-8 panels of 8″ x 12″ dimensions with ten coats of gesso, each using 8 ounces.

To control the amount of gesso to make, use four equivalent quantities.

1) **One dry ounce = 28.3495 grams, or rounding off to 28.0 grams, the weight of water found in one fluid ounce**

2) **8 fluid ounces = 1 cup**

3) **16 dry ounces = 448 grams**

Compare weight (compare dry ounces or grams) when making size, and compare volume (compare ounces or liters) when making gesso. For example, the weight of one ounce of water in grams to the weight of 16 ounces of water in grams is a **weight comparison,** and the volume of one cup of size to 1.5 times cups of chalk is a **volume comparison.**

I use the amount of the gelatin or animal glue's dry component found in one **dry ounce.** A dry ounce is the amount of a dry substance that will weight the same as that of water in one ounce. **The dry-ounce weight measurement is used only to create the size. Use ounces volume measurement to make gesso.**

Calculate the Gesso Amount

The fundamental size- weight ratio is one dry ounce (28 grams) and 16 dry ounces (448 grams) of water.

I want to prepare half the amount. The 1:16 ratio will produce too much size for my purpose. Instead of 16 dry ounces, or 2 dry cups of water, I want to use 8 dry ounces or one dry cup of water. I must also divide the gelatin (or animal glue) in half. I split one dry ounce (28 grams) by half to equal 14 grams. Since one dry ounce is the weight of one ounce, we can write :

The new formulation for the size:
1/2 dry ounces (14 grams) of gelatin or animal glue: 8 ounce (224 grams) of water.

The fundamental volume ratio for gesso is 1.5 once of chalk for any ounce of size.

To prepare the amount in the fundamental ratio, I measure two cups (16 ounces) of the size prepared and add it to 3 cups (24 ounces) of chalk (1.5 x 2 cups of size = 3 cups of chalk).

It would result in too much gesso for my purpose.

To prepare half the amount, I must use one cup (8 ounces) of size and add it to one and a half cups (12 ounces) of the chalk (1.5 x 1 cup of size =1.5 cups of chalk).

The new formulation for the gesso:
One cup (8 ounces) of size: one and a half cups (12 ounces) of chalk.

Material for making size and gesso

Animal glue is a collagen-Hyde pulverized product.

Animal glue is generally considered more robust and more durable than gelatin.

Rubles Tempera Ground

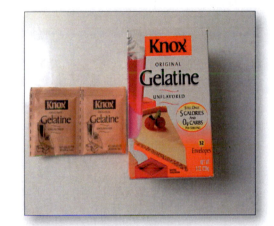

Knox Gelatin. It's a collagen -Bone pulverized animal product available from local supermarkets and online. Knox gelatin has the advantage of being easier to prepare and clean up, and is also less likely to produce a yellowing or darkening effect over time, which can be a concern with some types of animal glue.

A new innovative product by ArteFlex under the brand name " Rublev Tempera Ground" is a gesso made with a synthetic polymer binder. The Rublev ground is highly absorbent, unlike all other acrylic gesso products. It comes pre-mixed in a container ready for immediate application. The binder is Rublev Fluid Medium, available as a separate product. Despite its impressive absorption, the animal glue chalk ground continues to feel more retentive when painting. Nevertheless, The Rublev Tempera Ground is probably the synthetic polymer gesso tempera painters are waiting for. I am using it with good results.

Slash pine. Studio painting. Tempera and oil on hardboard primed with chalk ground. Mixed Technique, 8″ x 9″.

Support Panels

Assemble a wood panel before the gesso preparation. Hardboard, HDF/MDF boards, plywood panels, and solid wood are possible wood materials. The last two are available in different wood types. My preference is a wood pulp panel known as a hardboard. If using solid wood or plywood, glue a linen cloth to one surface to prevent the wood's grain pattern from eventually showing through the gesso and paint. Hardboard has a protective coating, known as tempered, some claim to ultimately affect the ground and color. To remove it, sand the panel until the a slight sheen on the surface disappears. In over 25 years of using many tempered panels, I haven't had a single issue with residual coating reacting with the ground or paint. The Masonite Company made an untempered board from wood pulp particles, which the Czech investment company, Door Investment s.r.o, bought. The panels are no longer locally available. Tempered hardboard panels are locally available. Other wood pulp panels are called high-density fiberboards or HDF or medium-density fiberboard or MDF, but I don't have experience using them.

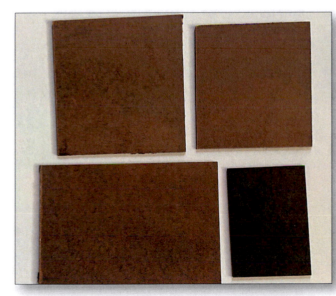

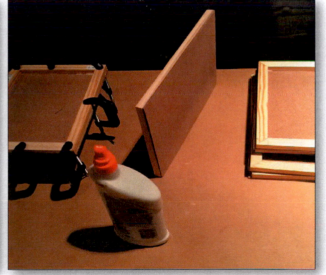

Panels cut from the 3′ x 5′ Hardwood panels available in hardware stores. The small dark Hardboard is made by Ampersand and sold with and without back support.

Assembled panels with back support.

To prepare the panel, cut a hardboard panel, HDF/ MDF board, solid wood, or plywood to the dimensions wanted. Next, prepare the back cradling that prevents warping and glue it to the back. Recently restorers are recommending that a panel not use a back support. They claim the stress in the board can eventually cause problems and crack the ground.[12] I haven't experienced any such issues. As I see it, the panel support bracing increases the panel's longevity by protecting the peripheral edge boundary.

Therefore, I brace the back to prevent the panel from warping, strengthen it, and protect the corners. A ¼″ x ¾″ strip of square wood molding is adequate. It is aesthetically pleasing, but not required, to meter the ends of the wood strips to the exact dimensions of the panel using a meter box. Glue the strips with wood glue. Place eight small clamps to hold the wood firmly for about one hour. Let the assembled panel dry for about 8 hours.

If you do not want to make wood gesso panels, I recommend working on a four-ply or eight-ply hot-pressed Bainbridge illustration board. This paper product, firm and smooth, is a reasonable stand-alone alternative to any of the boards conventionally used. It is acid-free and archival. Cut with a mat knife; it does not need any preparation. But it can be sized with gelatin, animal size, or the Rublev Fluid Medium water-soluble polymer to strengthen its surface. Use it as a support panel for the size gesso. If you use the illustration board as a support panel for the gesso, cover the back with the gesso to prevent warping. As with wood panels, place wood molding in the back for further strengthening and to protect the sides of the board. The advantage of using the paper board is the ease of cutting and preparing the panel. The drawback is that it is weaker than wood.

Bainbridge board. 8 ply 1/8" thick.

A small 5"x 7" 8-ply Bainbridge board primed with Rublev Tempera ground is ideal for plein air painting.

The panel back is covered with Rublev Tempera ground, black paint, and 1/2"x1/8" wood molding support.

Assembled Bainbridge board panel with back support.

Use wood glue to cement the wood mounding and plastic clips to hold them in place.

The most recent support invention is Aluminum-composite material panels-ACM. I use those made by Arteflex and sold by Natural Pigments. ACM is likely the most rigid and possibly the most archival panels available. These do not require back support. They are thin, 1/8", and very rigid. The drawback, they're expensive. They come prepared with one surface coated with polyester for ground application. Although I prefer using the Bainbridge board because it's light, water absorbent, and relatively less expensive, I speculate that for paintings greater in size than 12"x 16", the danger of warping or physical damage increases. Hardboard with or without back support is much more robust but heavier and cumbersome. The ACM boards are light and rigid and, therefore, better for as support for large work. A tape test performed by egg tempera painter Koo Schadler revealed size gesso chalk ground fails to adhere well to the polyester coating.[13] She recommends a linen cloth be glued to the board using BEVA adhesive before priming.

Two aluminum plates form the top and bottom with a solid polyethylene core. It's 3 mm thick, or about 1/8". One surface has a polyester coil coating for ground application.

ACM panel

Chalk Gesso Preparation

Supplies:

1) Hot plate
2) Double Boiler
3) Large sieve
4) Assorted measuring cups
5) One table spoon
6) Cheesecloth
7) Gelatin or animal glue
8) Chalk
9) One rubber band of moderate size
10) One 4"-6" house painters brush
11) A thermometer- optional

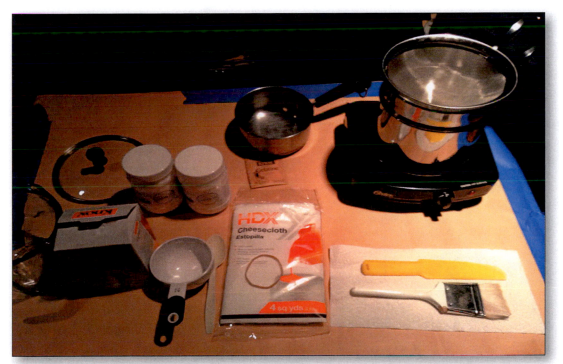

Size and gesso application set up. A work table is covered with brown paper. From right to left: A hot plate . A double boiler. A large sieve on top of the double boiler. A clean container. Bottles of chalk. The cover of the double boiler useful for keeping the solutions warm. Measuring cup . The Knox gelatin . A spoon. Cheesecloth. A moderate size rubber band. A 4" brush and a plastic stirring rod. A thermometer is recommended to measure the temperature of the solutions, but I never use it, preferring to visually monitor instead.

To make 8 ounces of gesso, first, make the size. Measure 14 grams of gelatin or animal glue in a balance and place it into 8 ounces of water. Pour the solution into the top pot of a double boiler. A double boiler is two pots on top of each other. The bottom holds hot water, and the top pot has the fluid to be warmed. The top pot receives heat from the hot water below. It prevents the principal substance from boiling. The mixture gradually becomes a gelatinous semisolid. The gel mixture is warmed in the double boiler until it is the consistency of water. Do not boil. To prevent it, some artists use a thermometer.

Once the gelatin-water mix is the consistency of water, use the 4-inch brush to apply the size to the assembled panels. Allow 8 hours to dry. Save the remaining size for the preparation of the gesso.

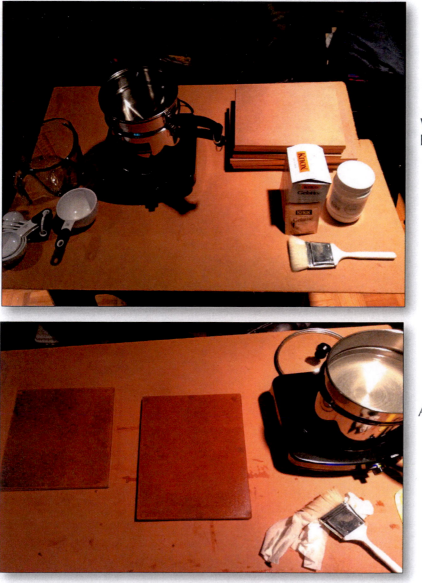

Warm the sizes without boiling.

Apply the size to the panel.

Measure one cup of chalk. Warm the size as before in the double boil to a water consistency. Do not boil. Place part of the chalk inside the large sieve and add the chalk gradually to the size. Use the spoon to gently help push the chalk through the sieve into the size.[14] The sieve helps to apply the powder slowly without lumps. It should fall from the sieve-like sprinkling of salt. It prevents air from being trapped in the liquid. Trapped air can result in pinholes in the finished panel.

Alton Sultan suggests using a spoon to gradually help push the chalk through the sieve into the size.

Chalk in the size.

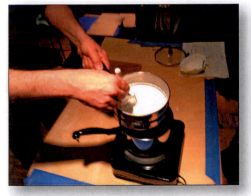

Stir very gently

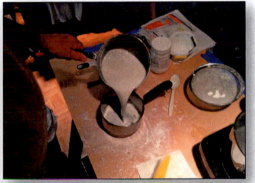

Pour the gesso into the clean container.

Cheesecloth cover the top pot held by rubber band. The clean container temporarily hold the gesso.

Filtering the gesso. Pour the gesso through the cheesecloth.

Place the top pot with the gesso over the lower pot filled with water in the double boiler. Stir very gently to even out the mix. The gesso is ready to be applied when it has the consistency of melted ice cream. To eliminate lumps and obtain a smooth fine mixture, filter the gesso. First, pour the gesso into the clean container. Attach a cheesecloth around the top pot's rim of the double boiler. Hold the cheesecloth in place by the rubber band. Slowly pour the gesso through the cheesecloth. If the gesso is becoming stiff, place it back over the warm lower pot until the hot vapor warms it and starts flowing again. Continue filtering until all the gesso is gone from the cheesecloth.

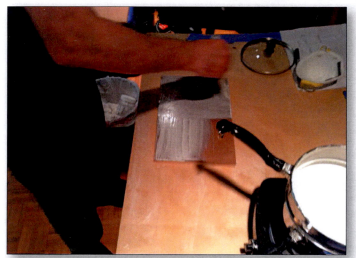

Applying the gesso. Let each layer dry to the touch before applying a new layer.

The last coat of gesso.

Remove the top pot from the double boiler, and with the end of the 4-inch brush, pick up a modest amount of gesso and apply the first coat to the panel. Traditionally artists rub the first coat on the panel with the brush and fingers. It helps unite the first coat with earlier applied size and thereby helps retain the gesso to the panel. Apply no fewer than eight coats.

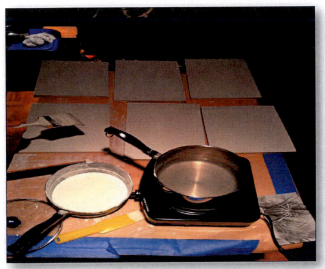

It takes about 5 hours to complete the application of gesso. The gesso is kept liquid by the heat of the double boiler bottom pot. Keep top pot lid on to retain heat but remove the upper pot from the bottom.

The completed gesso application. Set aside to dry for a minimum of 8 hours. To increase the gesso quality, let it cool and refrigerate for one to three days before applying it. Reheat without boiling.

Sand the rough surface of the gesso when dry.

Use a dust mask when sanding.

Sanding The Gesso Panel

Sand the panel carefully. Aggressive rapid sanding can remove too much gesso and even expose the underlying support. The goal is to remove the rough top uneven areas to achieve an even, smooth satin finish. A gradual process works best. To be sure the entire surface is sanded, begin sanding at the center of the panel. Advance the sanding circumferentially, gradually moving toward the edges. Use a mask when sanding.

Begin sanding with low-grade rough sandpaper. It will remove the most uneven areas. Continue with sandpaper of medium grade to remove remaining rough, bumpy spots.

Alternatively, use an electric circular sander. But if used, take extra care not to over-sand aggressively. Start the sanding with the medium grade and change to smooth high-grade sandpaper soon after. The gesso surface should be even. Minor scratches are present throughout, but the panel surface should be flat when viewing it sideways.

Complete the sanding with extra fine paper. Car finishing sandpaper helps remove the last scratches.

Electric sander.

Assorted sandpapers. Rough,medium, fine, and car-finishing sandpapers.

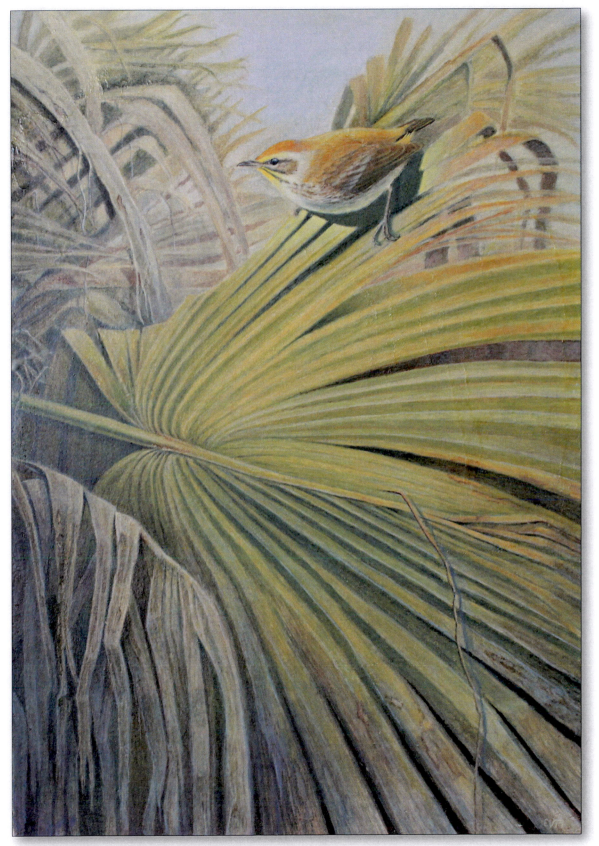

Palm Warbler. Studio painting, Egg Tempera on Hardboard primed with chalk ground, 8" x 12 "

Pigments

Cramer Pigments in New York and Natural Pigments are excellent suppliers of pigments and chalk. Other mass suppliers like Jerry's Artorama or Blick will carry pigments. Before using the pigments, guard your health and follow the following precautions: always know the pigment's chemistry implications, and read the safety precautions associated with its use as painting pigment. Use the Internet for information, or check the books suggested in the bibliography. Not all pigments are toxic, but many are. However, all pigments are harmful to your lungs. For preventive reasons, assume all of them are harmful.

When handling dry pigments, always use disposable gloves and a respirator mask. Once the pigment combines with water or the medium, a respirator will no longer be required. I recommend always using gloves when painting.

Never eat or drink in the same place where you paint and mix pigments. Wash your hands thoroughly after painting.

Clean your work area after each use. Keep your studio clean and neat. After a painting session, never leave wet pigment on your palate. It especially applies to pigment paste. This paste is the pigment mixed with water. The mixture will eventually dry and may release pure pigments into your work area.

Here is an option to consider. If you prefer not to use dry pigments, pigments suspended in water called Rublev Dispersions, sold by Natural Pigments, can be used. They appear a bit like ink dyes. Once mixed with the emulsion, they work similarly to traditional pigments except for a bit leaner. Another option is to use watercolor or ink. Use them initially to try out the medium or permanently to avoid the possible toxic exposure of using dry pigments. However, although commercial watercolor paint mixed with the yolk-water emulsion seems to behave similarly to the one made with dry pigments, it subtly performs differently. The working time will increase, and the paint will flow more like watercolor. It is due to the yolk-water emulsion combining with the additional content of the watercolor paint, such as Gum Arabic, Glycerine, preservatives, and other components.

Paint made with dispersions practically feels the same as that made with pigment paste. But, because the pigment particles are small, the color may lack the more substantial body obtained with the pigment paste.

Besides the quality of the paint film, there are several reasons to use pigments. For example, assembling your paint using dry pigments is very satisfying. A unique

capability, possible only with the pigments, is the potential to make oil paint expeditiously and to add resinous additions such as varnishes or alkyd. This flexibility to shift the binder to oil and back to egg tempera facilitates using the mixed technique. The following is a list of the pigments I use:

1	Cadmium Yellow Light	10)	Chromium Oxide Green
2)	Cadmium Yellow Medium	11)	Ultramarine Blue
3)	Cadmium Yellow Deep	12)	Prussian Blue
4)	Cadmium Yellow Lemon	13)	Ultramarine Violet
5)	Yellow Ocher	14)	Prussian Violet
6)	Burn Umber	15)	Quinacridone Red
7)	Cadmium Red Light	16)	Cadmium Orange
8)	Cadmium Red Medium	17)	Titanium White
9)	Viridian	18)	Mars Black

The most important of the pigments is the opaque Titanium White. It controls the handling and character of the paint film. Adding a bit of white will make the resulting color more opaque, and the paint will become more malleable and substantial, facilitating the **optical blending** of values. The addition of small quantities of white enhances specific pigment colors. Significantly, white helps make the paint appear nearly opaque, depending on the number of layers. Use white to help model the forms of objects with only white and another color of various opacities (referred to as **optical grays modeling)**. This layer is called **monochromatic underpainting.** Overpaint the initial monochrome layer with more transparent paint using lesser quantities of white. This movement from opacity to transparency is the fundamental technique of the early oil Netherlandish painters and most later European painting methods. [15]They used opaque lead white instead of titanium white.

Modeling the form with opaque paint, and overpainting with progressively more translucent colored layers, is a classic technique used in nearly all 14th to 19th-century oil paintings. This is a technique borrowed, or a continuation, of the initial tempera painting techniques before oil painting, spread throughout Europe. However, unlike oil paint, one does not need to wait several days for the color to dry before applying the new paint without lifting the lower layers. **Modeling in monochrome followed by a colored layer enables a division of labor between drawing and painting.** This process is very natural and easy with egg tempera.

The drawback of using white in the layer following the first monochromatic opaque layer is the possible inadvertent lightening of the values. It is especially troublesome with egg tempera. Its value range is lighter than oil. On a 7-value scale, with the oil maximum darkness being 7, the maximum darkness of egg tempera, compared to oil paint, is about 5+. I recommend never sacrificing the value of the painting by adding white to help blend colors or make them more opaque. After each use of white, constantly adjust to the intended values using black.

Black is, for me, the subsequent most crucial pigment after white. Here are a few facts about using black in egg tempera painting: using black to help darken values will not dull your color. It can change the hue and lower the intensity of a color. But the resulting colors will not look dull or muddy.

Because of tempera's low refractive index, black has a decisive function in increasing a color's value.

Black has the darkest of all values. Adding black to a dark pigment can simulate the darker tones we associate with the oil medium. Without black, you could try to darken the value of a color by increasing the number of layers of a dark pigment until the paint film is almost opaque. But its value range will only change modestly because the refractive index of the paint did not change.

Oil has a vast value range. From a very dark value to a brilliant highlight. **Its extensive value range is the oil medium's most distinctive advantage over Egg Tempera.** Oil is excellent for dramatically modeling form, painting deep dark shadows, and obtaining exciting saturated color. Because of a higher refractive index, oil painting has less need to use black to create deep dark shades. Not so with egg tempera. The darker colors will likely look lighter than you intended. Therefore, black is essential. It lowers the value range of color.

For example, adding black to Prussian blue will result in a darker blue. The hue of Prussian blue will remain translucent and transparent. Tempera is said to be unsuitable for painting dark pictures. I don't think this is true. One can paint with dark tones, made even darker by adding a bit of black.

It's important not to assume that adding oil to the yolk-water emulsion can remediate this disadvantage. The yolk-oil emulsion will maintain a lower refractive index. The only way to increase the refractive index is to add a varnish or alkyd to the emulsion or to apply the varnish over the dried tempera paint layer.

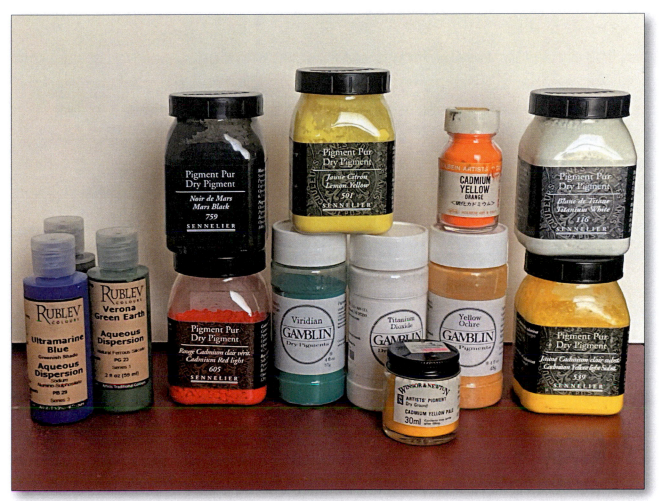

Examples of pigments. Gambling, Sennelier, Winsor & Newton are manufacturers. On the left are the bottled Rublev aqueous dispersions.

Preparing pigment paste

The difficult way to make the paint is to constantly open the dry pigment bottle, pick up a spoonful of pigment, and mix it with the emulsion every three to five minutes (the working time before the paint dries is about 2.5 minutes). That takes time. Much pigment is lost when the paint dries before you can use it. Furthermore, your risk of contamination with pigment dust will increase since your constantly exposing yourself to it. Instead, preparing and storing pigment paste is the best way to safely disperse the pigments, save time, preserve supplies, and expeditiously have a wet working mix available.

Pigment paste is the pigment mixed with water into a slightly thick paste; the consistency is like soft butter or ice cream. The pigment is milled lightly-modestly (dispersed) with a bit of water. The paste is collected and placed in an air-tight container when deemed sufficient. As long as it's in an air-tight container, it will not lose water to evaporation. It assures you that the wet pigment water mixture is available for use. It will also help in reducing your repeated exposure to dry pigments. An advantage is that the air-tight containers will make it easy to transport the pigment paste, which is vital if you want to work outside.

When painting and ready to temper, collect a pea size amount of the paste and place it on your palette, add a few drops of the emulsion, and stir with the knife. Pick only the amount of paste you need from the air-tight container, and leave the rest untempered.

The mini-paint containers are available in art supplies stores, Amazon, and Alibaba.

Air-tight plastic containers are ideal for storing pigment paste.

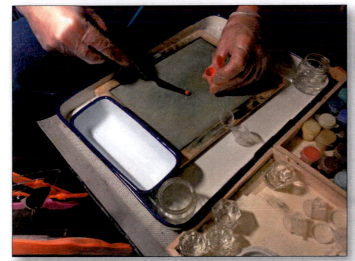

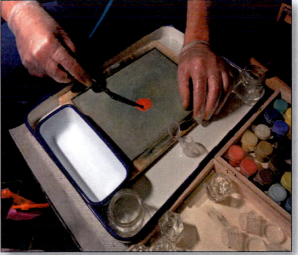

Carefully open the container with the required pigment. Use the palette knife to pick up a pea size quantity of pigment . The amount extends about ¼ inch from the tip of the blade. With practice, the quantity you obtain will be surprisingly consistent. Note the double-angle knife. A straight knife will not work as well.

Place a few drops of water into the pigment. Let it sit for about one minute to let the pigment absorb water. Do not mix until the pigment is wet. If you do so before it has absorbed the water, the dried pigment will scatter in all directions. After the pigment has become sufficiently wet, stir the mixture gently. A consistent, modestly applied force over time gives you more control to disperse the pigment, resulting in a denser paste.

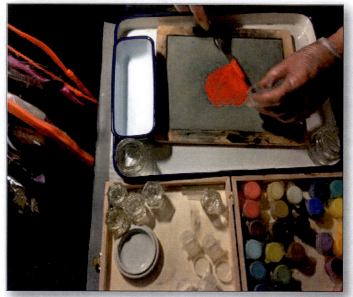

After several minutes of milling the paste, melted butter or ice cream should be the consistency. Pick up the paste mix with the tip of the palette knife. Continue this action until the paste fills about half the knife's blade. Pick up the empty air-tight container.

Tap the inside center of the empty container. The paste will slowly deposit into the container. Continue tapping until most of the paste is inside. Close the lid. It makes a snapping sound when completely closed airtight.

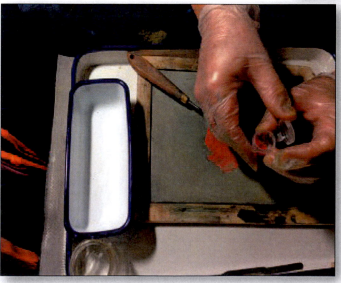

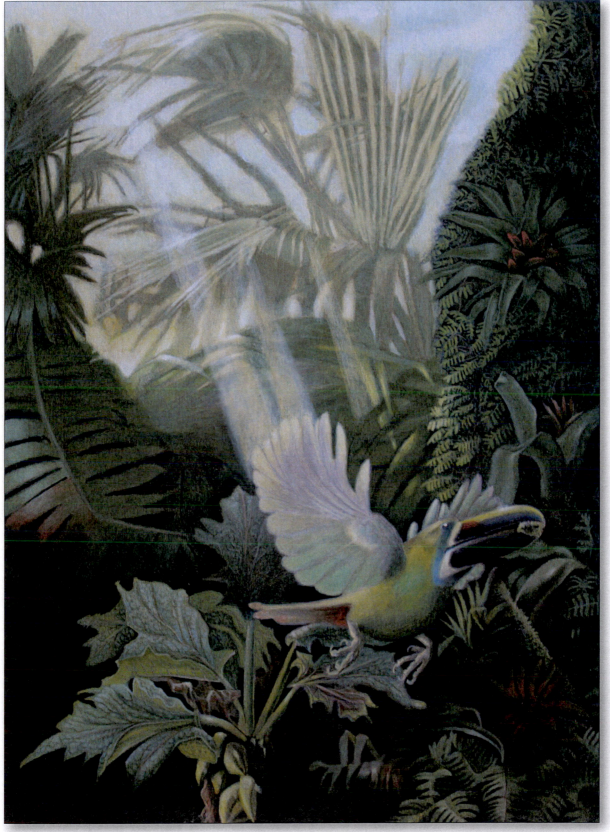

Up from the Darkness. Studio painting. Egg Tempera on ACM panel primed with Rublev tempera ground, 16″ x 20″.

Brushes and other paint Applicators

Practically anything that will mark a surface is suitable for applying the paint. The choice will depend on the effect aimed for. I'll mention what I use. However, brushes are most likely needed regardless of how the paint applies at a stage in the work process. Since egg tempera has a thin paint film, any stiff, rough brush will likely remove it. For me, the best brushes are soft watercolor brushes of any size and shape, and the workhorse brush used in all my paintings is the Winsor & Newton Sceptre Gold number 3 series 101, round brush. It combines sable hair with synthetic fibers enabling the bush to act like a pure sable but at a reasonable price. Regardless of the brush quality, I've found that it will lose its point quickly, but the Sceptre gold is quite resistant.

Flat watercolor brushes are next in usefulness. I occasionally use a soft fan brush.Besides conventional brushes, a toothbrush or Dremel rotary bristle brush can spatter the paint by running a finger over its surface. Sponges of all sorts can create many textures.

An airbrush can spray egg tempera. The film falls as a dry, even layer. Although limited in creating smooth gradations, its primary use depicts atmospheric effects. I don't use it, but instructive to know.

The technique of scratching out the paint with a pointed tool, called **sgraffito**, to create fine lines and expose an underlayer is straightforward and effective. A variety of tools are available, from dental instruments to sewing needles. The judicial use of sgraffito helps create small details and textures.

Egg tempera can easily be removed entirely by a damp paper napkin. Partial removal to different degrees is possible using soft to hard erasers, which permit limited removal to creates various effects.

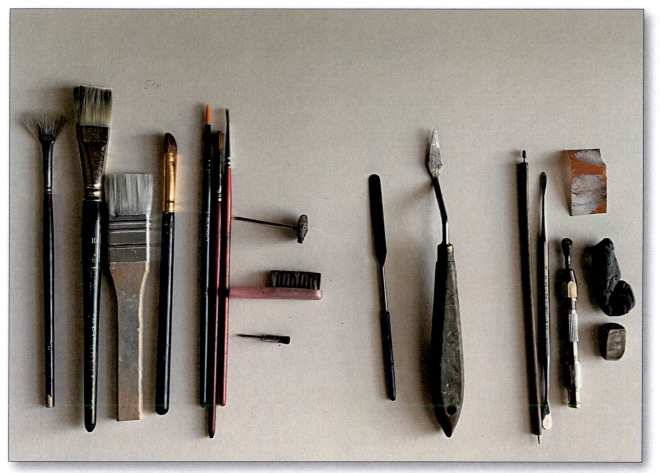

Paint application tools used in most painting from left to right: fan brush, flat watercolor brushes, a cosmetic brush, round brushes, toothbrush, Dremel bristle brushes, painting knives, homemade sgraffito tools- sharp pointed, dental wax spatula, pear shape carbide bur, soft and hard erasers, and sandpaper.

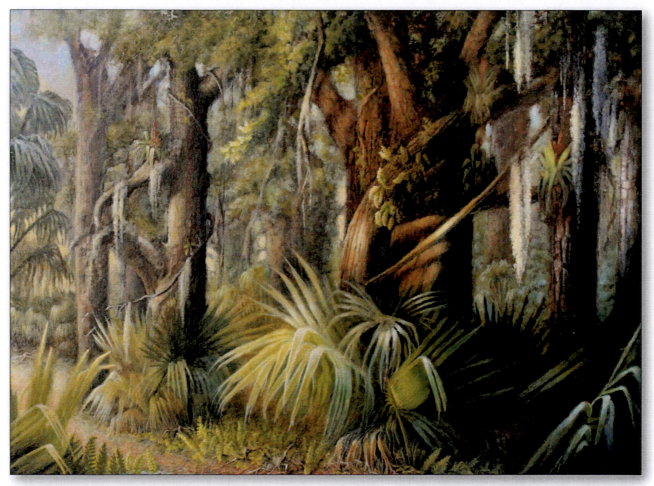

Florida Jungle. Studio painting. Egg Tempera on Hardboard primed with chalk ground, 8″ x 12″ .

Mechanics of Egg Tempera Painting

Fundamentals constraints

It's possible to formulate four constraints of egg tempera painting resulting from the material characteristics of the paint film. If not remembered when painting, it will likely result in frustration and eventual physical failure.

Four constraints of egg tempera painting:

1) **The paint should not be re-dissolved once it dries**. Apply the paint mark and let it be. Place the next mark, relate it to the first, reinforce its visual quality, or diminish it. But be definitive, and let all these applied color marks combine gradually without removing any of them to create the effect you seek . Water will dissolve the paint but not just reactivate the paint film as it does with watercolor. In watercolor–dissolving doesn't significantly weaken the paint film. The colors stay unchanged. Not so with egg tempera. The paint won't ever have the same paint quality it had before it dried. Instead of re-dissolving the paint, the water restructures the paint. It permanently destroys the polymer molecules that form the paint film. You cannot, for instance, paint a color next to another different color, let both of these dry, and later use a wet brush to re-dissolve the paint to mix the two colors. It will never work well. Or perhaps you want the color to be in a different position and wish to re-dissolve the paint to "push it" to a new place in the work. That won't work, either. Instead of the original paint quality repositioned to a new location, you'll end up with a dull, light color mark unacceptably different from the first. It is the result of having destroyed the paint layer by re-dissolving. Of course, you can remove all the paint film with water or by scratching some of it off, and then start again from the beginning, building back the layers of paint with new permanent strokes, followed by more permanent strokes, to a new acceptable definitive finish.

The constant removal of paint frustrates the picture-making layering process. Removing incorrect paint marks destroys the carefully built-up layers. Therefore corrections by removing the paint force one to start layering again. As a consequence, this delays the picture's advancement through layering.

2) **Don't paint in wet, thick layers.** Thick layers of paint will ultimately crack. All applications, thin or thick, of egg tempera paint will dry fast to the touch, but water will continue to evaporate from the thick paint. These moist films continue to expand and contract as the water evaporates, and the contraction will cause a thin layer painted above the thick layer to crack.

3) **A firm, steadfast support for the paint is required.** Egg tempera, in time, becomes very hard and insoluble in water but also brittle. The paint film will crack in the flexible support.

4) **The paint works best if the ground is water-absorbent.** The best foundation for egg tempera is a calcium carbonate material bound together in size as gesso. The paint's absorption into the gesso ground will facilitate adding many layers of color without the lower layers separating.

These restrictions result from the material quality of the egg yolk-water emulsion, and the same conditions apply to successful yolk-oil emulsions. There are no limitations beyond these. You can apply the paint with anything imaginable that will work in the purse of any aesthetics.

Paint Application Basics
(For a detailed exposition of this topic, see Appendix I and II)

Premixed **tones** of different values contribute an important foundation to my way of using egg tempera.[16] The tones, mixtures of pure colors, and various values of gray create a malleable translucent paint film allowing quick optical blending and a denser film. To construct a tone, pick any color and mix with it equal amounts of black and white. Alternatively, incorporate the black and white into a gray of any value and mix it with the color. The more gray, the lower the intensity of the color. A tone gradation, or tone scale formation is possible.

To create a middle tone, mix equal amounts of black and white.

To create a light value, add more white to the gray middle tone.

To create a dark value, add more black to the gray middle tone.

Add the gray to the color. Adjust the quantities of black and white and the color to refine the desired value and intensity. It is straightforward and predictable.

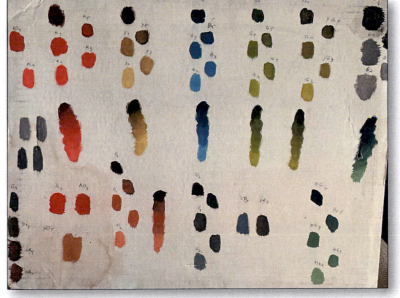

The Tone Scales created by mixing the three premixed pigment paste tones, form the foundation strategy for color application.

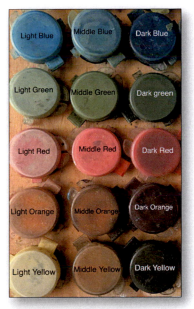

The three-Tone Scale assemblies are in the pigment paste containers set.

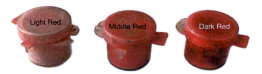

Red Tone Scale pigment paste

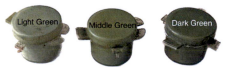

Green Tone Scale pigment paste

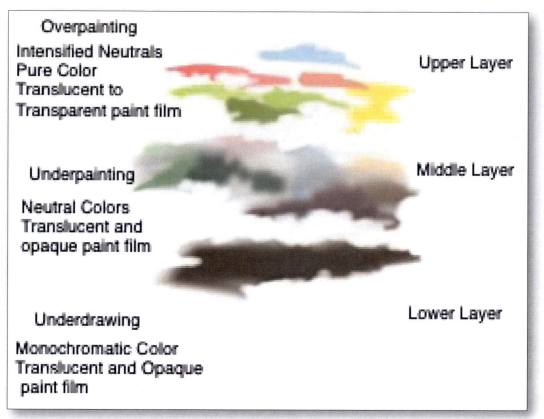

Generalized schematic of the painting process.

The gradual reduction of the gray in the tone as layers increase, terminating with only pure color, facilities control of both form and color.

The illustration demonstrates a generalized schematic of my painting process. The method permits developing forms in the lower layers, followed by top layers of greater intensification of chroma and introduction of new colors. Based on current research, the Netherlandish Renaissance painters used a system similar to this.[17] The underpaintings were egg tempera or oil, and the overpaintings were in oil. In my paintings, the underpaintings are egg tempera. The overpaintings are egg tempera (sometimes combined with Grassa) or the Mixed Technique oil-tempera combination.

Varnishing

Egg tempera paintings remain easy to damage for up to a year. It takes about six months for full plolymirazation. At this time, as a final step, they can be polished to an even sheen with a soft cloth. However, a varnish finish can be applied to protect the surface.

The best I've found is Krylon Mate Finish. It's an acrylic spray varnish. Apply one coat evenly from a distance of 12 inches. The results look identically to the unvarnished painting, except the surface looks perfectly even. Another reason for varnishing is increasing the refractive index to saturate color and deepen values. Use a gloss varnish for that purpose. I use Winsor & Newton Artisan Gloss Varnish. It's painted on and forms a thin, even finish. You can varnish with the Krylon spray afterward for a mate finish. Even though the finish is perfectly mate, the refractive index remains high in the Gloss Varnish area.

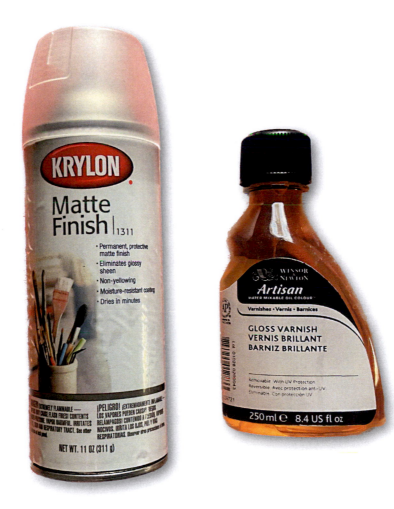

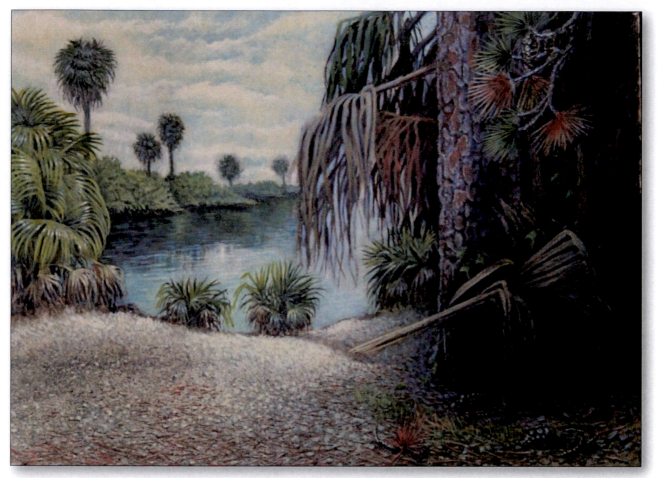

Before the Storm. Studio painting. Egg Tempera and Egg-Oil Emulsion - Grassa on Bainbridge board primed with chalk ground, 5"x7".

Painting Strategies and Aesthetic Concepts

Two Approaches

Painters generally create art using two strategies. One is **conscious and deliberate**, with the subconscious **perceptions** contributing as an essential factor, but they're kept in check by formal **structures** that organize the **visual elements.** The purpose of structural organization is to help limit the number of choices, thereby enhancing focus that results in efficient, creative manipulation.

The second strategy painters use to create art is an intuitive approach, arranging the visual elements in an immediate **gestalt**[18] response to the evolving picture, with subconscious perceptions as the most crucial factor in the process.

Although image-making doesn't fall clearly in one or the other but uses both, it tends to gravitate to one of the above ways. Studio painting emerges from a greater dependency on deliberate, rational cognition, and the plein air picture relies more on a subconscious process.

Even though egg tempera can be approached deliberately in a studio approach or subconsciously, as in plein air work, it's traditionally used only in the studio. The suggestion of the studio method is in the book by Cennino Cennini.[19] Contemporary analysts of past egg tempera paintings reveal individual variations for creating an egg tempera painting change with the artist using the medium. However, the conceptual fundamentals remained unchanged throughout the 15th century. I call the technique of Renaissance Italian egg tempera masters the **Classical Tempera Method.**

The Classical Tempera Method, CTM

This ancient but efficient and highly successful method was probably imported to Italy during the 12 century from the Byzantium Civilization.[20] Known at that time as the maniera greca-The Greek Manner, it likely originated in the ancient Greco-Roman times.[21] The Classical Tempera Method is simple but powerful. It's also easy to learn.

The Classical Tempera Method is organized, sequential, craft-oriented, intellectual, and precise. The goal is to gradually, by patient effort, enhance the probability of creating excellent, predictable results.

The Classical Tempera Method divides into four steps:

A: *Exploratory*: To learn the subject and plan the **value design** of the painting, make drawings, and prepare a **color design** to arrange the color.

B: *Modello*: A master drawing, called the **modello**, is imaginatively created from the drawing studies and transfers as an outline to the panel.

C: *Underdrawing*: A value drawing (monochromatic) in ink, watercolor, size, **metal point,** or egg tempera is made on the panel using the modello as a guide. This underdrawing can be simple or highly detailed.

D: *Painting*: Following the values of the drawing as a guide to the color's value and the hues of the color design, the monochromatic underdrawing is deliberately and slowly overpainted with color. Although any color may be used at any time, traditionally, more opaque and gray tones are in the first several layers. Gradually, the upper layers become progressively less opaque and more saturated with pure color. The most intense and transparent colors in the final layers are last. This sequence is a logical progression from no hue to maximum hue and intensity. This technique provides the most control of the paint. The colors traditionally used to increase opacity are opaque white and gray, made by mixing white and black to neutralize any color. I used Titanium White and Mars Black; both are opaque.

Originally used as the egg tempera technique in the late Middle Ages, the Classical Tempera Method was the starting point for the painting technique of other mediums up to mid 19th century.

At that time, a direct, opaque, and simultaneously color-value application of the recently invented tube paints replaced the layer strategy in all media. Most painters

today use this manner of painting, referred to as **ala prima.** Although first used in the Dutch Golden Age, its use was limited, unlike today. The common practice in the past, generally labeled as the Indirect Method, was the standard practice because it enabled more control of form and color and a more comprehensive range of representational effects.

Its success primarily lies in effectively dividing the work into the investigation and invention of form, and the related illumination, from the organization and expression of color. Value design, illumination, volume, proportions, structure, anatomy, perspective, composition, and more, are all addressed in monochromatic drawings. Consequently, the painter is free to choose colors for the painting for their intrinsic beauty and harmony, unrestrained from the constraints imposed by the representation. In the Indirect Method, the final picture represents the graceful fusion of form and color.

Interestingly, this painting method is parallel and consistent with how the brain separately encodes visual information for value and color. In the thalamus and occipital cortex, the human brain processes the signals of value separately from those signals it receives from the color of objects. Separate cells distinctly encode for illumination and color.[22] The resulting neural codes are sent, as an electrochemical impulse, to the frontal lobes, where it combines with prior memories forming the perception of what we see.

As a student of egg tempera, I recommend you begin making your painting studies with the Classical Tempera Method. It is the best way to learn how to control the paint in egg tempera. You will also learn the traditional construction of most European paintings before the invention of tube paints. After working with the method and achieving paint control, you can proceed to a different technique and perhaps never paint in the Classical Tempera Method again.

The following demonstration is an example of a painting made using the Classical Tempera Method. In keeping with the **classical** aesthetic of the Renaissance, I've created an idealized picture. It's life-like, but doesn't represent a naturalist reality. The painters of the Renaissance wanted to represent a perfect world, known as **Platonic perfection;** it's a timeless, absolute, unchangeable world, made of ideal forms that exist beyond the variation of observed reality. The transient effects of light and atmosphere, valued by naturalistic painters, are deliberately repressed. Instead, the goal was to understand the tactile anatomical physical structures defined and

separated by clear boundaries, the representation of space and three-dimensional volume, the harmonious use of color, and a beautiful, expressive design.

Passing Angel Painting

In the Florida winter, there's a bird, the palm warbler, common wherever trees and shrubs are. Like all warblers, the bird rapidly darts through the branches hunting insects. One moment, there's the warbler, and the next, it quickly disappears. The bird is beautiful, almost magical in appearance, and I feel grateful to witness this miracle of nature.

My response to the experience begins by drawings what I remember from seeing the bird in the early spring morning just before it migrates north for the summer. It's my initial visual idea.

I proceed by making quick drawings of the Live Oak tree branches. Later, I search for pictures and descriptions of the bird. Field guides and ornithology textbooks on bird anatomy help understand the bird's form. Museum-preserved skins of the bird allow direct inspection.

I make detailed drawings of the branches and their leaves, anatomical illustrations of the bird, and notations of the colors. Now there are sufficient facts to think with, and I start inventing the modello. Using the initial drawing idea, I play with the drawings, manipulating their juxtaposition, size, and values and varying their shapes.

Once a configuration is deemed acceptable, I construct a **three-dimensional model** of my concept using clay and paper and light the model with a lamp directly in the direction the ideal drawing suggests.

The model is essential to determine the true light, shadow, and perspective empirically. It reveals the light's effect on form as it intersects with the model. Simply imagining how the cast light and shadows look is unconvincing and false to my aesthetic. Using this model as a guide, I modify the modello as needed.

I'm ready to proceed with the color design. Using the local colors of the subject to guide my selections of colors, I look for **analogous** colors and their contrasting **complementary** colors.

I make a copy of the modello to over- paint it with my color strategy. Once satisfied that the color scheme will work, I transfer the modello's outline to the panel. The modello's outlining, the **cartoon**, is transferred using tracing paper and a

graphite 0.5 mechanical pencil. The paper, stained in the back with black pigment, transfers the outlines to the panel by going over the pencil outline with a dull metal stylus. The values, and small details aspects of the modello, are rendered freehand.

The ink drawing precedes applying color, but unlike most egg tempera painters using the Classic Tempera Method, I prefer to work by sections rather than complete the entire ink drawing before applying color. I draw with ink-selected parts of the work, then overpaint color to the part I've drawn.

I proceed this way, underdrawing with ink, followed by the color application of all the separate sections. For example, I complete the bottom left and then paint the upper right of the panel, and after that, I paint the top left, followed by the lower right.

As the work develops and new dynamic relationships form between the colored areas, I frequently return to earlier sections to modify their forms. This holistic approach helps me critique and change the painting. At the same time, it allows maximum paint control and the comparative visualization of the sections. I call it the **modified part approach.**

The paint film is applied very thinly using parallel hatching. Careful premixing of intermediate values is essential to paint soft transitions. For instance, between light and dark green lies several transitional values. Low light green, middle tone green, and high dark green. There're five values together, including light and dark green. Premix the values to paint smooth transitions. Working from the darkest, dark green, proceed by carefully painting parallel hatch strokes, modulating gradually to the lighter value away from the darker until the highest value of light green. There're dozens of translucent layers of paint applied, frequently in different contracting hues. The painting process is enjoyable; unexpected colors optically emerge, you lose track of time, and the activity seems like meditation.

The modello is a general guide for the work, but minor essential modifications are common and inevitable as the painting proceeds. This deviation is beneficial and appropriate. The artist must always remain visually responsive to the emerging painting, maintain inventiveness, and create interrelated harmonies throughout the work.

There's much satisfaction in creating a representation of what the artist perceives as perfection. Unlike the naturalistic aesthetic, where random unexpected light effects are valued and desirable, a consciously defining delineation embodies each idealized form in the classical aesthetic.

Passing Angel combines natural forms and colors with idealized concepts. The result is a modified reality that aims at an aesthetic of perfection. I believe that the Classic Tempera Method excels in this approach.

The following sequence of photos illustrates the Classic Tempera Method. Notice how it progresses from imagination to factual investigation and back to a final synthesis of both; unlike in medieval times, where memory and imagination were deemed sufficient to create an image, humanism and a new focus on the material compelled the artist of the Renaissance to search for truth empirically.

A) Exploratory Phase

The process begins with an initial idea—a drawing from memory of the experience. An honest exploration of the subject by drawing is made from life. They are naturalistic. That is, they're literal rendering of the subjects as seen. The purpose of this phase is to acquire objective information on the topic.

 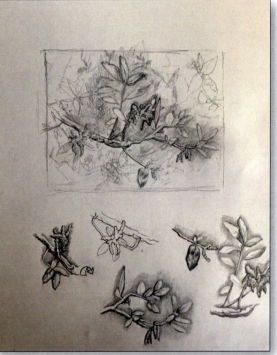

Initial memory drawing made with ink and pencil on paper.

Pencil on paper.

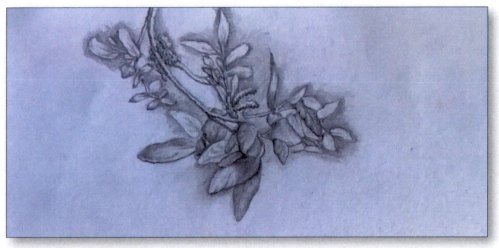

Pencil on blue paper.

Goldpoint on prepared paper.

Pencil on blue paper.

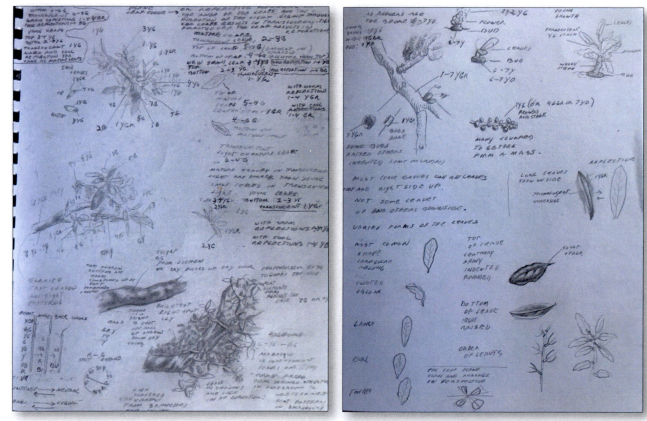

Color notations, pencil on paper.

Leaf study, pencil on paper.

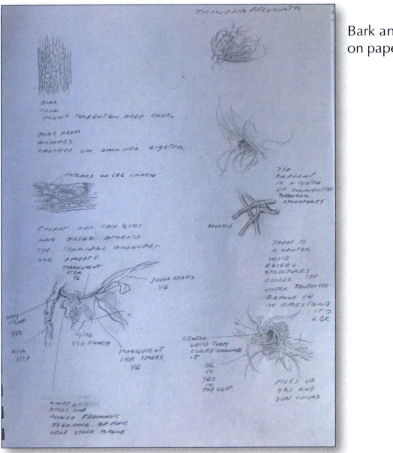

Bark and epiphyte study, pencil on paper.

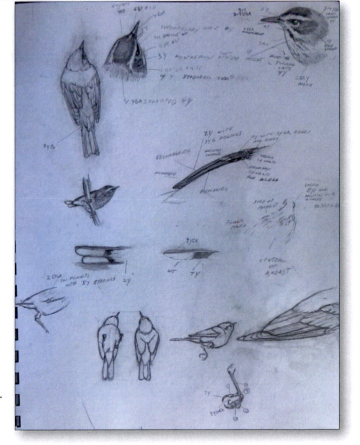

Bird study, pencil on paper.

B) Modello Phase

I manipulate the drawings into different configurations of size, position, values, and shapes until I find a compelling arrangement.

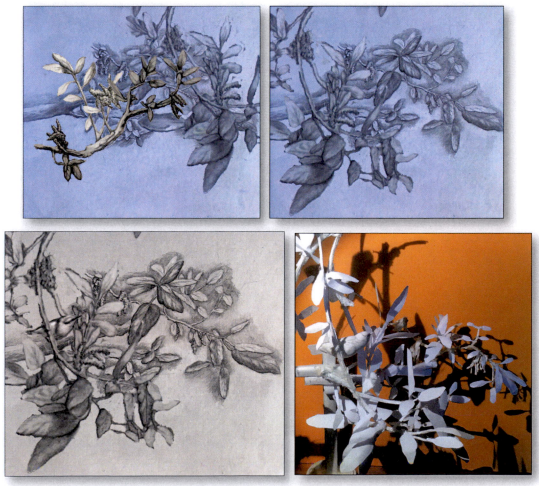

The tree branches, leaves, and the bird's preliminary arrangement are complete.

A three-dimensional model of paper and clay is constructed and illuminated in the desired direction of light to discover the true light and shade and perspective foreshortening of the forms.

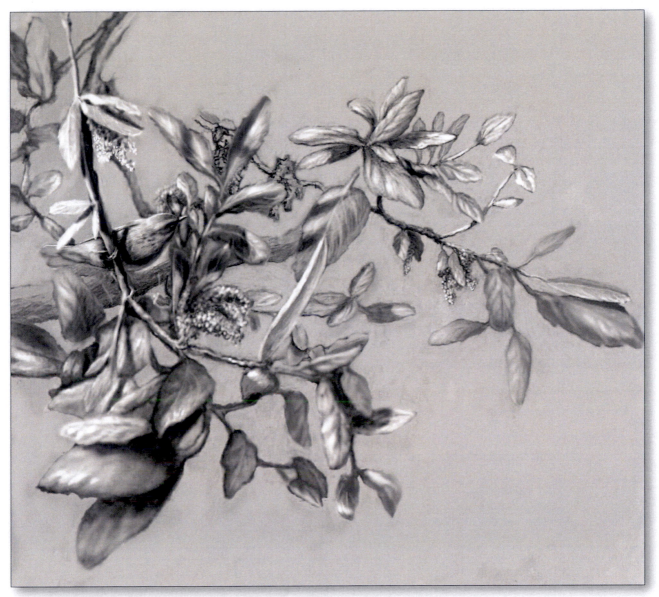

The complete Modello. Pencil, ink, white egg tempera on gray-toned Bristol board. It is ready for outline transfer to the panel.

Color Study

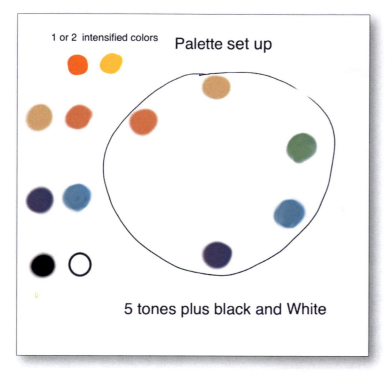

I've painted a copy of the modello to test the color structure. It's used only as a general guide when painting the picture.

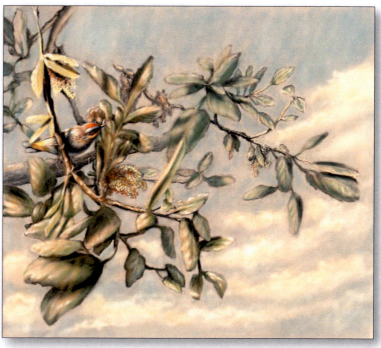

I use the traditional Newton **color wheel** to think about color. The starting point for the selection is the **local color** of the subject. For this painting, the yellow-violet split complementary structure works. I like a **limited palette**, and the colors are **neutrals** except the bird. The color are yellow, violet, yellow-orange, yellow-green, blue-violet.

C) Underdrawing and Painting Phase

Shown are the modello outline and commencement of the painting. Painted first is the lower left quadrant of the picture. Only the ink underdrawing is complete on the top leaf.

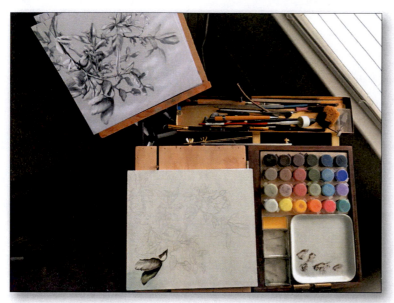

Painting setup. The modello guides the painting together with the color study.

Slowly and carefully, the color applies in many layers. Perfection of form and beauty of execution is the goal.

The process continues systematically, unrelentingly, in the same manner, calmly, perceptibly adjusting the picture as it unfolds until it achieves a final resolution.

The Classic Tempera Method enables the artist to paint anything imaginable, regardless of its existence, and simultaneously imbued the picture with a clear sense of objective truth. The Renaissance artists wanted to conceive an idea in their minds and express it in the visual language of nature. They never copied anything literally and presented it as the final picture. They drew from life to learn and used the knowledge to serve their idea.

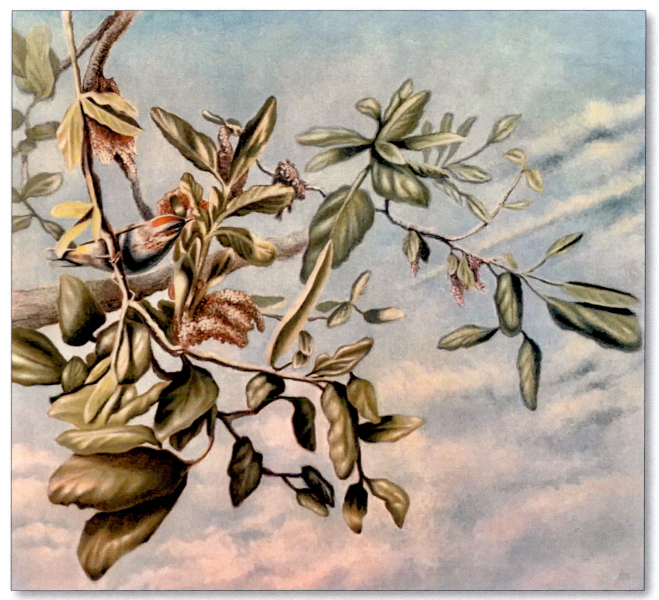

Passing Angel. Studio painting. Egg Temperra on Hardboard primed with Chalk ground, 8″ x 10″.

Classism, Naturalism and Realism

The fundamental goal of naturalistic art is to depict what the mind sees as it perceives reality. It is, of course, as much a fictional pictorial illusion as is the classical esthetic of imagined ideal beauty. They differ in the degree to which the work derives its characteristics from empirical observations or the concepts the mind forms about what constitutes perfect form.

It's important to remember that merely representing a subject's observed or remembered structural actuality will result in scientific accuracy but can lack a compelling organization. Work demonstrating accuracy and an expressive abstract design achieves the highest attainment.

There's a difference between naturalism and **realism**. Frequently used interchangeably, the emphasis of the work, in naturalism, is predominantly the artful depiction of immediate observed reality.[23]

In realism, the artist attempts to paint an absent subject, whether it exists or is imagined, as though painted from reality or to edit an existing naturalistic picture to create a better composition. Thus realism uses naturalism as a foundational starting point for pictorial invention.

The Direct Egg Tempera Method, DTM: The Naturalist Method

Overview of the Method

When using the **Direct Egg Tempera Method,** there's no Modello drawing transfer to the panel. If the work is from life, the painter chooses a subject in nature or assembles it into a compelling arrangement if it's a composed still life. Chosen is the viewing position, light direction, time of day, and weather conditions for the painting, and the work starts immediately on the panel. If the work is from preexisting reference, the conditions are as they appear in the reference. The DTM is the method of the naturalist painter.

In naturalism, the purpose of the work is to appear analogous to reality. The work's visual arrangement imitates the subject's visual relationships and avoids exaggerated distortion from this configuration.

Not ignored but limited are the modifications of the subject to accommodate the picture's **abstract composition** or **expression**. Essential for the design is that

representation of a subject's **actuality** must be very selective; therefore, it is not a portrait of everything.

Carefully considered is the cropping of the visual field and placement of the shapes in the format. Similarities of appearance between portrayed subjects and consistency of execution further unite and **balance** the work.

The maximum naturalistic artwork achievement is creating a visual survey on a subject constructed using an insightful composition.

The Drawing - Painting Cycle

In naturalism, the artist begins with a **schematic** drawing representing the assumption of what the mind sees.[24] Rarely is that assumption perfectly **congruent** with the subject. The schematic drawing, therefore, must be corrected. The artist compares the subject with the drawing, notes the apparent discrepancy, and corrects their differences.

This cyclical process continues until an acceptable **correspondence** emerges between what the mind sees when drawing and what it sees when looking at the subject. Because this is how a naturalist image forms, the artist must be willing and capable of constantly adjusting the painting-drawing.

Comparison Between Oil and Egg Tempera for Direct Naturalistic Painting

Oil paint has the advantage of being very physically malleable. The paint film is pushed and dragged to a new position. It remains workable for many hours. This physical flexibility permits the constant adjustment needed to create a naturalistic image.

Comparatively, you might believe that egg tempera is inflexible and unsuitable for naturalism because the paint dries quickly and cannot be dissolved and repositioned. But this would only be true if you think like an oil painter. The paint is visually malleable and easily adjusted if one understands egg tempera. **Even though egg tempera paint can not change physically, it can infinitely adjust optically.** Consequently, egg tempera is just as flexible as oil, constantly visually repositioning to enable the representation of what the mind sees.

Recall that a critical restriction of egg tempera painting is to place a stroke of paint and leave it without attempting to change it by re-dissolving it. Therefore, achieve corrections by drawing a new mark in a different orientation than a prior mark. Because the previous mark persists, this way of working can use the preceding mark as a **salient point** of comparison. It thereby helps to estimate where the new

mark will be. Once the position is correct, emphasize the location of the latest mark by adding new ones on top.

Comparison between the DTM and the Classical Egg Tempera Methods

A fixed outline of the drawing mainly persists throughout the Classical Tempera Method.

Although modifications are possible in the CTM, most of the drawing exists before starting the painting, and the tracing paper mechanically transfers its outline from the modello drawing to the panel.

Instead, in the DTM, the drawing's configuration develops empirically and gradually as the work emerges from observation. In other words, the drawing constantly changes in the DTM.

The constant optical adjustment of the drawing's contour is the main difference between the Direct and the Classical Tempera Methods.

Surprising new arrangements not foreseen earlier appear, and the final results are wholly more unpredictable than in the CTM of painting.

Although in the DTM the drawing changes, the medium's constraints remain the same because Tempera's paint-film characteristics don't differ from the Classical or the Direct. As a result, the painting process is similar to the CTM. The painting begins by drawing with an initial monochromatic layer and applying paint from more opaque and neutral color layers to more transparent and saturated color layers.

Any details are possible with the monochromatic color, but it's best to keep the drawing simple and not detailed with only the large shape of the value relationships expressed. This drawing is an overall value design. Even though a simple underdrawing will usually suffice, it will include textures and details if these remain visible in the final layers.

Following the value design, once the drawing seems sufficient, gradually overpaint with neutral layers of tones. As the work develops, create textures and details. In the final layers, place transparent and intense pure colors where needed, strengthen highlights, refine details, and accentuate darks.

There's one other significant difference from the CTM. In the CTM, the paint strokes are kept parallel, and the intermediate value's premixed to enable smooth transitions. It is less crucial in the DTM to premix intermediate values where painterly loose strokes and abrupt value changes are preferred to express a dynamic reality.

The varied brushstrokes are better for expressing light and time's transient, unpredictable, and surprising quality. It's also more practical and quicker than the Classical parallel strokes-a desired characteristic when painting from life.

The Direct Method Sequence

1) Gestalt: A spirited, quick, gestural line- value drawing is made with a silver point to block out the composition.

2) Value drawing : Create a monochromatic value drawing using a dark neutral color, sometimes highlighted with opaque white. Sometimes, this drawing only comprises the primary value shapes to create a value design. At times textures and details are invented if they'll show in the final work.

3) Underpainting: Grayed opaque to translucent tones are gradually painted following the major value patterns. These become increasingly intensified and transparent as the layers increase. Create the textures of surfaces at this stage.

4) Overpainting: The final layers of paint are transparent with pure, intense, saturated colors where needed, refined details, and strengthened highlights and darks.

Plein Air Painting: Landscape painting using the DTM

The most frequently cited objection to using egg tempera for plein air work is transportability, and secondly, that it takes much time to build up the layers of paint.

Painting in egg tempera is generally slower than in other mediums. It can take longer to complete a painting of a similar size. The application of the paint can feel labor-intensive and time-consuming. To overcome this obstacle, create only small plein air works. The best sizes are 5"X7", 6"x9", 8"x10", and 8"x 12". These small sizes allow one to finish a painting to completion in one to three sittings averaging about 5 hours each.

For support, I use the Bainbridge illustration board. I used to coat these boards with size gesso, but currently use the Rublev tempera ground.

Generally, I complete one painting in the morning or the afternoon. I work about 5 hours. If I need more time, I return to the same spot at the same time and the same weather conditions to continue. True, it's not easy to work with pigments outside. As a result, many egg tempera life studies use watercolor or gauche. Sometimes egg yolk is added, and the results are good. I prefer using the same pigments and medium outside as in my studio work. It helps me maintain consistency.

The Plein Air Set Up

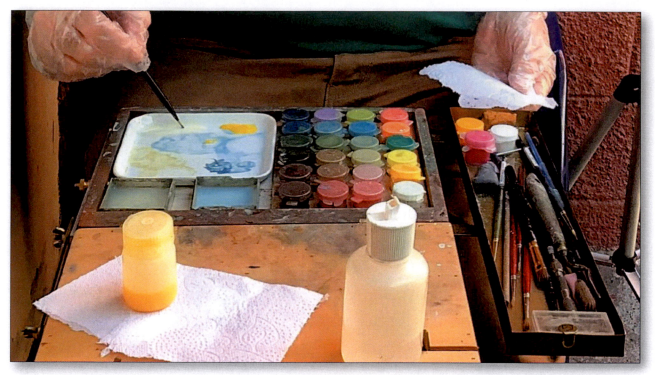

The Plain Air work setup.

I transport pigment paste and the yolk in small plastic air-tight containers. Other essential supplies are a water drop dispensing bottle and a palette knife used to dispense the yolk medium and mix it with the pigment. For a palette, I use a shallow ceramic dish. For a pochade box, I've tried several and eventually settled on Open Box M Palette/ Panel Holder. These compact boxes are hand-made to order. They come in four sizes. I use the smallest. It allows to hold up panels to 8″ x 10″ size. There are many manufacturers of Pochade boxes, and the choice is a matter of personal preference.

A Manfrotto camera tripod holds the Open Box that can be used as a work table when fully opened. If used as such, then an iPod holder- many kinds available-can be fitted to a second tripod to use as an easel for holding a panel.

A folding chair and an umbrella, sometimes used for shielding from the sun, completes my setup. I carry the entire supplies in a backpack bag.

I carry the entire setup for Plein Air tempera painting in a modest-size bag.

In the picture of the setup, notice the small color airtight containers for the pigment paste. To orderly hold the containers, I've made a wooden flat 5"x7" platform transversed with rows of drilled holes that maintain the containers in place. A metal brush holder on the right of the containers, made specially to attach to the Open Box, holds brushes, sponges, palette knives, scratch tools, and other supplies. I placed a ceramic sushi dish on the left side of the containers, which is ideal for a small palette. It holds the paint and the dispatch medium.

At the front of the palette, there's a small airtight bottle to keep the yolk medium, and to the right, an airtight water bottle with a drop-top used to dispense water. The drop-top precisely places water drops in the pigment paste containers when needed.

The two small plastic containers at the front of the palette hold water, one to clean brushes and the second to contain clean water. The components can change position from right to left.

Paper towels are a must to wipe the brush and clean. I use a small palette. Since egg tempera dries very fast, mixing large amounts of different pigment pastes is unnecessary. A small palette is easier to clean and contains only the paint needed for immediate use.

Note that I'm using disposable gloves to prevent pigment paste from drying in my hand.

The picture on the opposite page shows the side view of the plein air setup. A Manfrotto tripod holding the Open Box. An 8"x12" Bainbridge gessoed board, suspended by the iPad-holder serving as an easel, is attached to a second tripod. The arrangement suits the precise, concentrated effort I need for egg tempera painting—the position of both the Open Box and the easel iPad holder change by moving their tripod.

Side view of the Plein air setup

An iPad holder attached to a tripod holds a panel allowing the Open Box to serve as a table.

A small tripod can become an easel by attaching an iPad-iPhone holder. Here it's holding an 8"x 12" panel.

The Open Box holds a small panel. Here a 5"x7" is sustained by the metal clips on the opposite side of the box.

There is a Resemblance Between Oil and Egg Tempera's Plein Air Painting

With its painterly characteristics, the plain air work in egg tempera is easy to mistake for an oil painting. Perhaps the oil in the yolk is responsible for the similarities, and we could re-classify egg tempera as part of the oil mediums instead of the water mediums, a kind of fast-drying water soluble oil paint.

Regardless of what it is, the ability to create an extensive range of values, the **lost and found edges,** the depiction of the atmosphere, and the natural color appear similar to nature.

Egg tempera facilitates these results as it can change from transparency to translucency or opacity. Oil paint can do the same, but unlike oil which requires the paint to dry before glazing and **scumbling**, egg tempera fast drying advantage enables these techniques immediately.

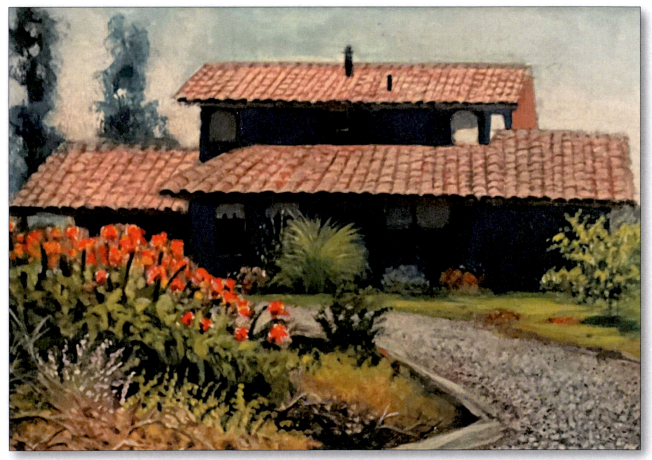

Country Home. Egg Tempera on Bainbridge board primed with chalk ground. 5"x7". This highly finished Plein air work took about 10 hours to complete. I believe it competes successfully wlth oil in enabling the creation of naturalistic effects.

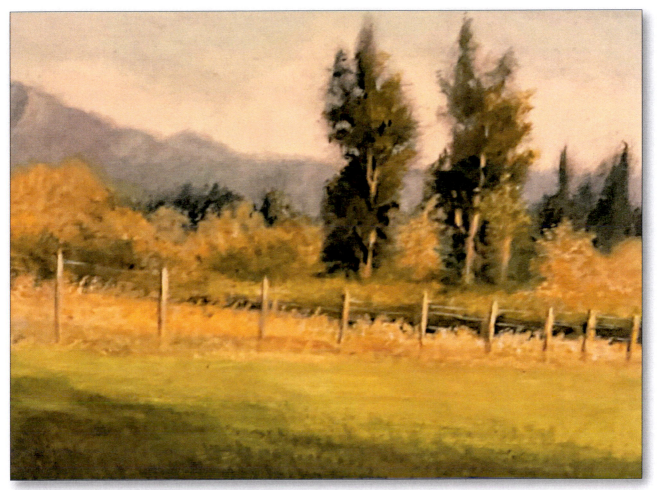

The Quiet Field. Egg Tempera on Bainbridge board board primed with chalk gound 5"x7". This work took approximately 6 hours. I believe there's an uncanny likeness to oil paint.

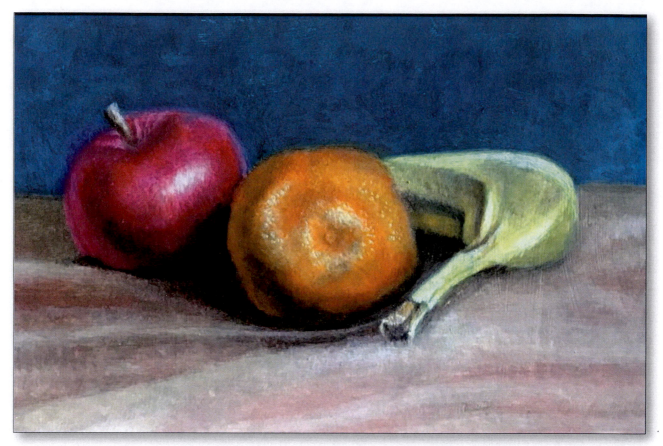

Still Life of Fruits. Egg Tempera on Bainbridge board primed with Rublev tempera ground, 5" x 7".

This painterly egg tempera still life observed directly from life took about 4 hours. Note the loose brush strokes, the varied edges from soft to hard, the vast range of values, and the natural color. Tempera can create the appearance of reality similarly to oil paint.

The egg tempera paintings below are unfinished. One depicts flowers found in my garden. Again note the oil-like character. Once the painter abandons the linear esthetics of the CTM for a painterly approach, an egg tempera painting resembles one made in oil. Note the warm and cool **chromatics**, painterly brush strokes, lost and found lines, and natural color. It shows that there is no innate restriction on the kinds of aesthetic egg tempera is capable of. It's instructive to see the blue-gray underdrawing still visible on the paintings.

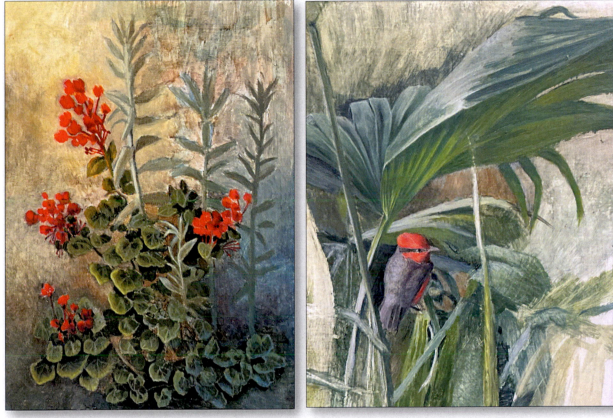

Unfinished work from life, 5 " x 7". About 4 hours of work.

Unfinished Egg Tempera, 8" x 10." Mostly a painterly approach, it resembles oil paint.

The Plein Air process

The Five Deterrence

There's what I call the **five deterrence** to plein air painting. I use it to decide if a plein air painting is possible. I choose where and if I can paint based on these restraints questions:

1) Is the subject permanent, or is it transient and changing?
2) Is it practical to assemble the setup, or is the spot inconvenient to paint from?
3) Is the site safe?
4) Is the subject approachable?
5) Is there reasonable privacy?

Notice I don't include the subject's appearance as part of the questions. Instead, I choose the subject I want to paint after I choose the site to set up.

Therefore, the work's primary aesthetic results come not from some prominent beautiful characteristics of a unique subject but from the quality of my perception.

In the following series of photos taken while painting a plein air picture, I illustrate the plein air process using the DTM. The site is at the Hillsborough River State Park in Florida.

The Forest Barricade

Using the five deterrent questions as a guide, I find a good place to paint in Florida Hillsborough State Park.

I transport supplies from my car to the site in a leather backpack.

I first opened the tripod that supports the Open Box.

Next, I assemble a portable folding chair.

The Open-Box attaches to the tripod and functions as the work table.

The pochade box fully opened as a work table.

The Open Box side can tilt and hold a small panel.

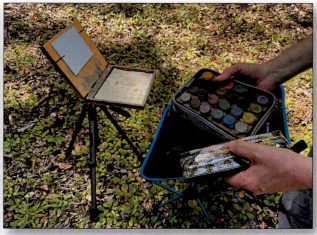

The pigment paste containers, brushes, and other supplies assemble inside the Open Box.

A metal brush holder attaches to the Open Box.

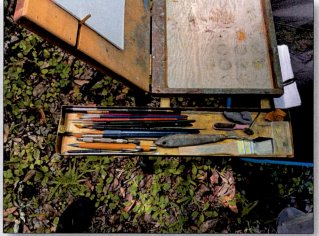

Brushes, erasers, scratch tools, palette knives, and silverpoint tools reside inside the metal holder

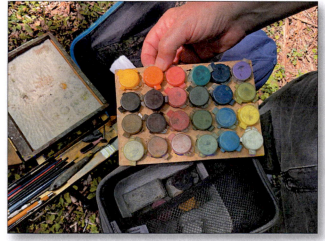

I place the pigment paste-container platform inside the box.

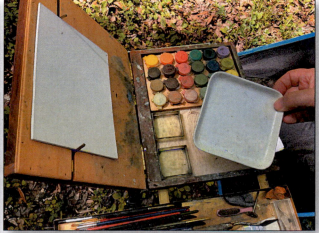

A square ceramic sushi plate is the palette placed next to the pigment-paste platform.

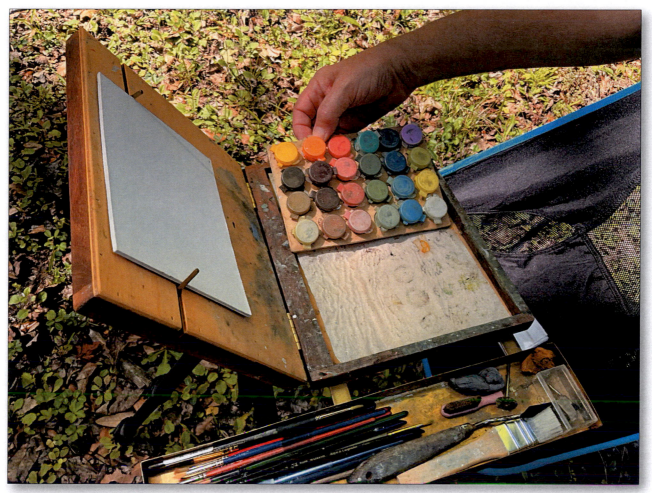

The pigment-paste containers are held in position by a wooden platform.

They're 24 containers held in position by a 5"x7" flat wooden platform with holes drilled to sustain the small containers. The hue and values arrange the pigment paste in different rows. There's a light value of a yellow **tone**, of an orange, and of red, green, and blue arranged in rows. In a similar arrangement are rows of middle and dark tones of the same hues. Tones are pure pigments mixed with varying values of gray. One dark tone for violet and light yellow-green are in a row placed together with the pure pigments of Cobalt- Violet and cadmium red light. There are additional pure pigments of cadmium yellow medium, cadmium yellow light, cadmium orange, viridian green, and titanium white. Not permanently kept in the wooden plate are Cadmium yellow deep, Cadmium red deep, and Mars black. The arrangement of the tones by values creates an orderly palette that facilitates quickly finding them as needed when painting.

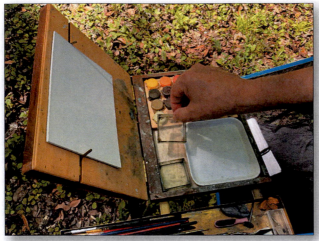

Two small shallow plastic containers hold water.

To enable the Open box to function as a work table, I assemble a second tripod with an iPad holder to be the easel.

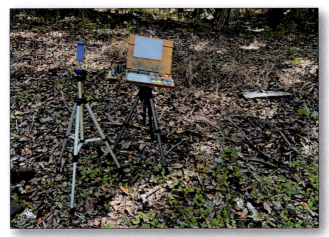

The tripod-iPad holder assembly functions as an easel.

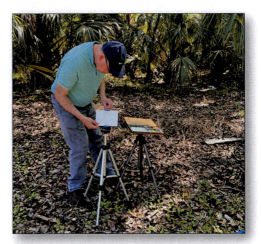

The panel held by the tripod- iPad holder is freeing the open box to function like a flat work table.

The yolk medium is in an airtight container.

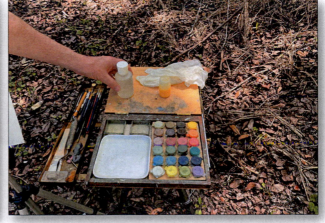

An airtight water container with a drop top and disposable gloves place on the Open Box work table.

An umbrella is attached to the chair to shield the work from the sun.

The painting setup is complete. Paper towels on the table are a must for cleaning brushes and the palette.

The work begins by looking at the scene intensely. Essential perceptions form unconsciously. I wait for a conscious awareness of what to paint.

It's vital to visualize a pictorial idea before starting work.

The scene. Reality is infinite in structure and complexity, but human perceptions are more specific. My intent is not photographic accuracy; it's an interpretive analogy. I ask myself, how can I use the language of paint to represent what my mind sees.

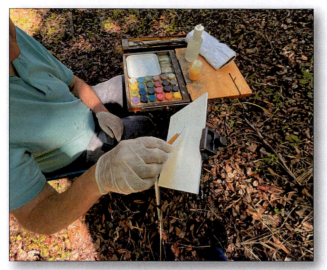

The gestalt drawing phase begins once a visual idea forms in my consciousness.

It's crucial at the start to resist the temptation to observe details. Instead, look for significant relationships between primary shapes.

The abstract gestalt drawing is complete.

I begin by relating the main shape with a Silverpoint stylus. Although the drawing is mostly very light and linear, it suggest values. A metal point is quick, indelible, and light. I find it ideal to start the work. I keep the marking very fluent and dynamic. At this point, everything's in flux as I observe the totality of the scene and develop the composition. This part of the process is spirited, intuitive, mostly linear, and emotional, lasting no more than 10 minutes.

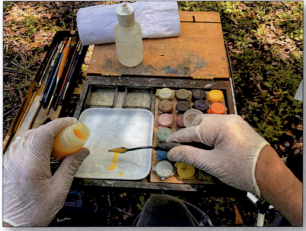

The value underdrawing phase begins. Using the tip of a palette knife, I pick up a small amount of yolk medium .

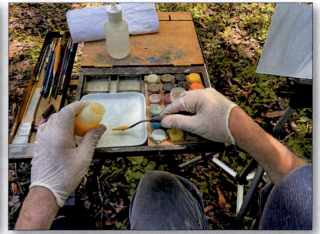

I place the small amount of yolk medium in the ceramic dish. It is needed only to temper the dark yellow tone pigment paste I use to develop the underdrawing.

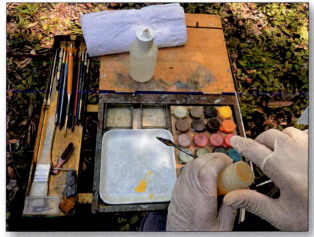

I'm closing the yolk container after each use to prevent spillage.

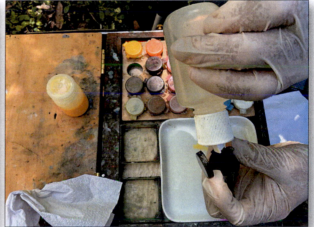

I add three drops of water to the pigment container to moisten the paste.

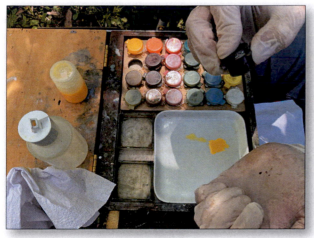

The container is closed firmly.

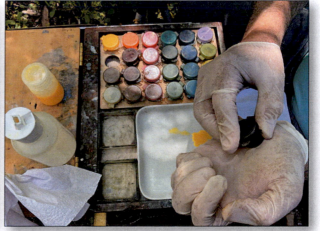

I vigorously shake the container against my hand to mix the water and pigment.

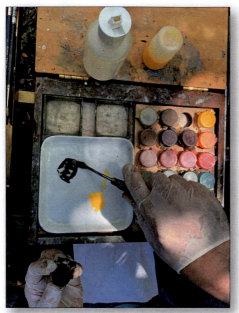

Use the tip of the palette knife, pick up the pigment paste, and grind it.

The yolk is tempering the pigment.

The process continues by determining the primary value relationships. I attempt to mentally reduce the infinite number of value shapes seen in nature to an abstraction of approximately **five values shapes**. This imagined simplification is an essential aspect of the work. The painting achieves most of its aesthetic merit as a result of it. It is the conceptual value design. But I create this abstraction briefly when plain air painting and only broadly suggest it since I don't see nature as only values shapes.

Instead, I see tactile surfaces full of textures within shapes of different values. This sensitivity to textures is one of the principal reasons I paint in egg tempera. Since tempera dries immediately, I can create the value-shapes and paint the texture within them, similar to what I see. I can't do that fast with wet oil paint, forcing me to paint only shape, value, and color, at least until the next sitting when the first layer dries.

The brush is dipped into the yolk and mixed with the pigment paste. If the paint needs additional grinding, I use the palette knife. I do not add water to dilute it, preferring a thin but dense dry brush. To create the quality of **thin-dense paint,** I wipe a lot of the color off with a paper towel before applying it to the panel. It allows maximum control of the paint film. Unless I want to remove the paint film altogether, I never change the position of the paint mark once applied. Instead, I add new patterns and integrate the prior marks into the multiple paint layers.

This way of working forms a cycle:

The Egg Tempera Drawing-Painting Cycle

Observe and apply a paint mark to express a perception, and observe and apply a second mark to paint new perceptions. Evaluate if the relationship of the marks to each other is congruent with the relationship of the forms perceived in the subject. If it's the same, leave it; if different, apply a new mark to correct the old perception. Do not remove the prior marks.

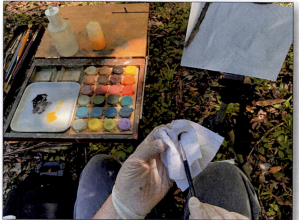

To create the quality of thin-dense paint, I wipe a lot of the color off with a paper towel before applying it to the panel.

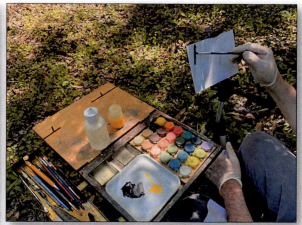

The first brushstroke.

I frequently pick the panel and hold it in my lap while painting. Note I'm painting with only dark yellow and the panel's white surface to create the values.

The Value shapes and textures gradually develop the underdrawing by the Tempera Painting -Drawing Cycle

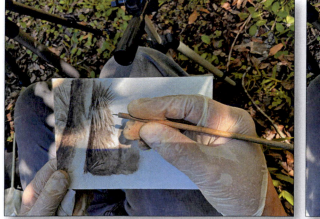

Homemade sgraffito tools- sharp-pointed, lift paint to reveal the Rublev ground.

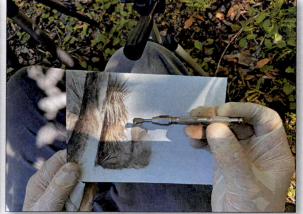

The pear shape carbide burr can lift varied amounts of paint, forming thin lines into wider shapes.

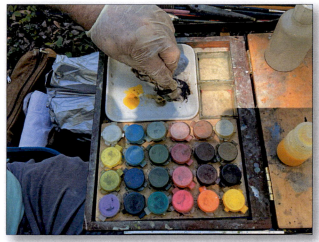

The round Dremel bristle brush can spatter paint and draw lines and shapes of various characters. I'm picking up color from the palette.

I'm drawing the shapes behind the tree with the Dremel bristle brush.

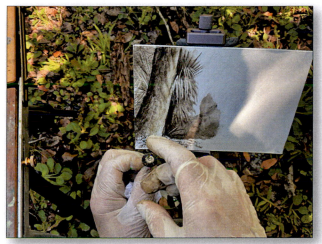

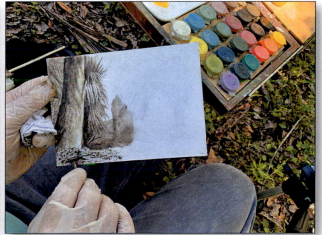

I create a granular texture for the foreground by running my index finger across the Dremel bristle brush to spatter the paint.

I'm developing the various texture shapes of the foreground with the Dremel bristle brush.

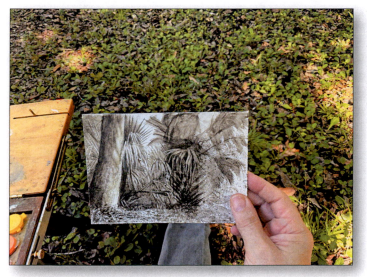

The drawing continues to form following the guide of the initial gestalt and the Tempera Painting-Drawing Cycle. Note on the right; I paint the flat value shapes of the palm leaves before introducing smaller ones on top that form their leaflets.

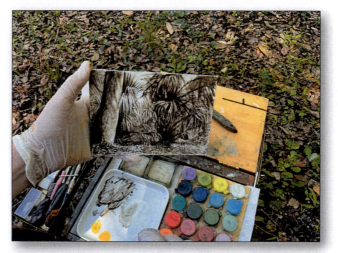

After approximately two hours, the monochromatic underdrawing is complete. I use no white paint, only dark yellow- or optical gray modeling technique.

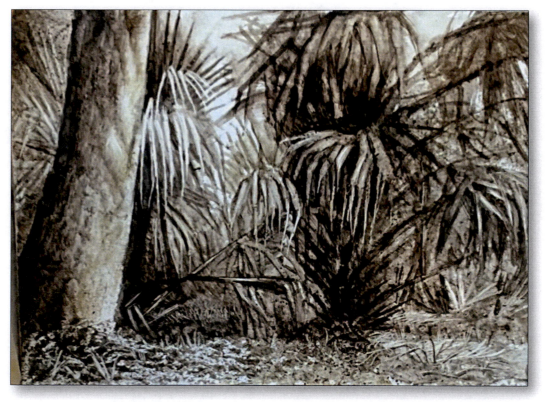

The afternoon light has darkened, and I must stop working and return another day if the weather is the same.

The painting aims to objectively represent what the mind sees using **the language of paint** and does so with an effective composition. Unlike a photograph, the depiction is **approximate and general,** not **specific and exact.**

The underdrawing is not passive; something to paint over until it disappears. Instead, It'll contribute its color and textures to the final painting.

The next day I assembled the setup as I did the previous day and started the underpainting phase with the darkest green tone.

Using the palette knife, I mix the yolk with the pigment paste.

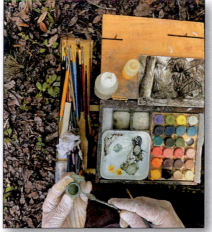

Looking at the subject and using the underdrawing's values as a guide, I over-paint the dark green tone where I believe it belongs.

I painted the darkest green areas with dark tone green, then proceeded with the middle tone and light tone green.

The pre-mixed color arranged by values permits me to focus on the subject rather than the mixing of paint.

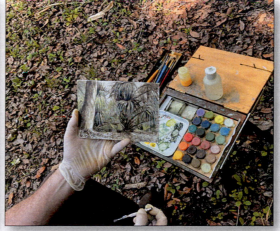

The underpainting color is neutral and translucent to opaque. The underpainting is complete and took about one hour.

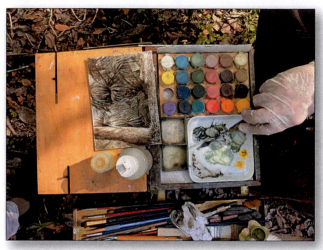

I began the overpainting with the leaves traversed by light and intensified yellow-green by adding cadmium yellow light to the neutral mix.

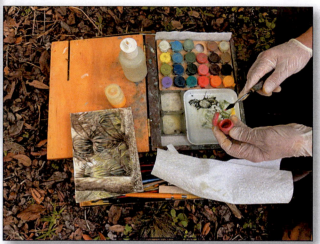

The complement of green is red, and it's present in the subject. I pick up the light red neutral from the container with the palette knife.

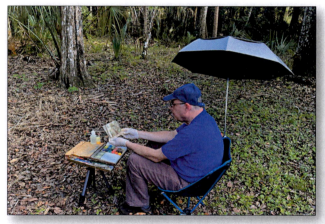

I evaluate if the relationship of the marks to each other corresponds with the connections perceived in the subject. If it's similar, I leave it; if different, I apply a new mark to express the new perception and integrate it with the prior marks.

Visual perception is mostly an unconscious process, and it's essential not to try to impose it on the mind deliberately. Instead, wait patiently, and perceptions will arise into awareness in time.

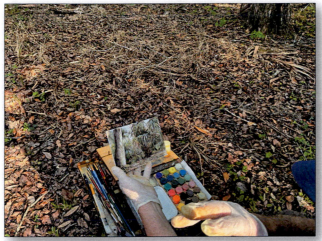

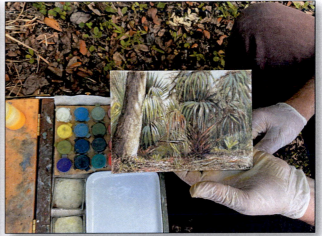

The overpainting includes pure transparent colors, intensified tones, and new colors. It is now complete.

In this work, the overpainting is quick. I darkened a few areas, highlighted others, intensified the yellow-green, and added a Cobalt Violet glaze on the tree bark. It took about one hour. I'm satisfied with the overall impression of the scene the painting describes.

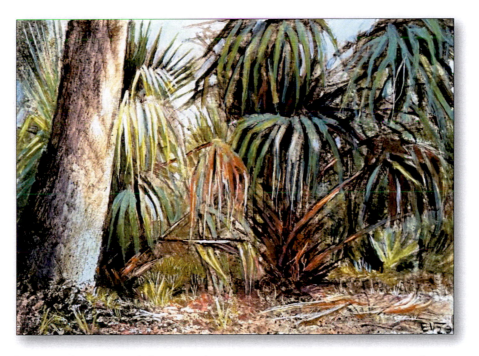

This work uses lines and lance shapes to represent various forms made with tools that create diverse textures.

The grid-like design has a frontal emphasis and an overall, even spread of forms. There's a modest focal point on the upper left of the painting by the highlight of the tree and the strong leaf reflection. The palm trunk's dark vertical reddish mass helps to balance the heavy **visual weight** of the tree's diagonal. The color has a green-red complementary structure. The representation is approximate and general.

The Realistic Indirect Method, RIM, and Classicism

I wrote earlier that realism, although related, is different from naturalism. Naturalism directly investigates what is real and represents it artfully as a design.

In realism, the artist imagines an image and wants to paint it as if it existed, or the artist wants to add to or change a picture of something that exists, such as adding an object or giving the image a better design, respectively.

Realism begins where naturalism ends. It maintains the philosophy of **truth to nature** but moves beyond it by allowing the imagination to invent. A realist usually paints away from nature. That is, indirectly.

In the importance realists give the study of nature and the indirect approach, their methods broadly resemble the Classical. But to the classicists, nature, as found, is imperfect; however, to the realist, its natural appearance embodies truth and is highly esteemed. Recall that the classic artist seeks to create beautiful, enduring qualities. These appear absent in a world of impermanence, uncertainty, and unreliability.

There is a longing for something more eternal. The classic artist seeks a reality that can transcend deformation and change. That search results in **ideal preconceptions** of what is lasting, harmonious, and beautiful. This ideal does not physically exist. It is a concept in the mind, an imaginary image. False is a deviation from this ideal, and the classic artist uses conscientious attention and deliberate selection to rid the work of dejected transient qualities. Creating perfection is the goal. Reality is adjusted to conform to an immutable ideal. To the classicists, perfection is the enduring optimal quality. It is **inner-directed.** The truth lies inside the self. The actuality of the natural world is flawed physical structures that are modified until they reveal their beautiful eternal truths. On the other hand, to the realist artist, the truth of reality is assumed to be outside the self. It is **outer-directed.**

Like a scientist searching the world for comprehension, the realist believes that increasing objectivity leads to understanding. The goal of the realist artwork is to represent the imagined objectively, as opposed to the observed for the naturalist, in a compelling and insightful organization.

A chronic problem plagues realism. Recall that naturalism creates art by drawing or painting nature using the Painting-Drawing Cycle. A subject must be present to observe for this process to work. But the realist mostly paints away from reality,

that is, indirectly. Therefore the process isn't applicable. Yet, the realist wants the painting to look naturalistic.

The problem must resolve differently than the classic artist's indirect picture painting process invented to depict the ideal form naturally. Therefore creating a careful Modello and transferring the drawing outlines to a panel will likely result in an idealization.

A boundary expressed by the outlines of classic art can't describe the transient qualities of light and movement. Natural perceptions are largely unpredictable, and realist methods should reflect this to potentiate the goal of a naturalistic appearance.

It implies that careful delineation of forms and a prioritizing concern for beautiful predictable results will likely fail to create a naturalistic illusion. A more intuitive, open process that invites spontaneous changes in the work stands a better chance of success in imitating nature when nature is not present to observe.

Given the realist respect for the facts, it is illogical to ignore the **actuality of the picture,** an object made of flat spots on a flat plain, and only focus on the illusion the flat shapes suggest. Both views are essential for structuring the painting: the shape abstraction and the representation. They're perceived simultaneously as **reciprocals** of each other.

The Realistic Indirect Method Sequence

The method enables the flexible manipulation of the picture's figurative and abstract aspects.

1) Choose one image to explore. Begin the work with an existing image, preferably with a painting from life or an imagined drawing approximating what something looks like.

2) Determine the shape characteristics of the image's forms. Find the approximate boundaries and transform the original image into a puzzle of interconnected shapes.

3) Reduce the image to no more than five values. Simplify the many values depicted from nature or imagined to a flat poster of no more than five values. The many smaller puzzle shapes are now within one of the large five-value shapes.

4) Reshape the original. Using the five-value shape composition, restructure a copy of the original image to resemble the design. Simplify this new image to five value shapes.

5) Consider the compositional structure, including the color. Notice how the **dynamic relationships** of the five value shapes combine to create an expressive balance design. Examine the **linear perspective,** the illusory **plains of space**, and the color.

6) Transfer the design. Transfer the value design to the panel by a grid, tracing, or freehand approximately reproducing the value shape design.

7) Gather many visual factual references on the subject. Any form of information that provides visual knowledge, such as drawings, paintings, artifacts, photographs, illustrations, and verbal descriptions. Create props and models to observe how light interact with three-dimensional forms.

8) Paint the picture. Using the value design as a foundation, use the reference freely, arranging and transforming the design to represent the subject while remaining an interactive and expressive composition.

The steps that follow illustrate the realistic indirect method.

1) Choose one image to explore.

Hammock Forest

There's a magnificent subtropical forest in John D. MacArthur Beach State Park in Palm Beach County, Florida. It's called a Maritime Hammock.

These forests grow on land several feet higher than the sea level. Before the arrival of the Europeans, they were commonplace and had gigantic trees. Mahogany, royal palms, gumbo limbo, and other tropical species were plentiful. These beautiful forests are now few and far between, and the mahogany trees have disappeared. But there's a sample of how it must have looked.

It was about 4 p.m.; the palms were casting long shadows. Fragments of dead palm leaves covered the ground. Fallen seagrass gave off a subtle red light. A grove of cabbage palms created a narrow shaded path that seemed frighteningly obscured by darkness. In the distance stood a sizable pink tree surrounded by

small, twisted-trunked trees. Slightly hazed by the atmosphere, it was an emergent Gumbo Limbo tree. There was an all-pervading silence. I felt a mixed feeling that was both sublime and frightening. Wishing to capture the scene before the light faded, I installed myself to paint.

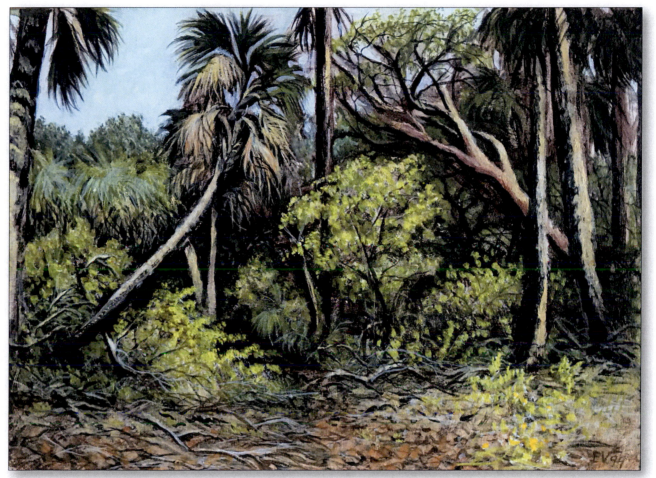

Hammock Forest. Plein Air Painting. Egg Tempera on Bainbridge board primed with chalk ground, 5" x 7". This visual survey is intended for use later in my studio to help create a picture that hopefully will express facts and my emotional and aesthetic experience.

2) Determine the Shape Characteristics of the Image's Forms.

It's insightful to reduce the picture to shapes separated by distinct outlines. This reductive approach reveals the work's two dimensional structure. Restructuring is primarily a repositioning of flat shapes to a different configuration.

Identify boundaries and reduce the picture to puzzle-like shapes.

3) Reduce the Image to no more than Five Values.

Simplicity in painting is a virtue. It's better to express more with less. In practice, simplifying the infinite values found in nature to a few values will permit better use of the restricted range found in paint. A few exciting shapes are more aesthetically pleasing, improving the abstract design, and the representation improves since the mind quickly grasps the illusion.

The five-value design simplification is black for the trees and middle ground, white for the sky and the highlight on the tilted palm, middle gray for the background and the bush at the base of the tiled palm, and low light gray for the foreground. The white outline helps see the shapes.

4) Reshape the Original.

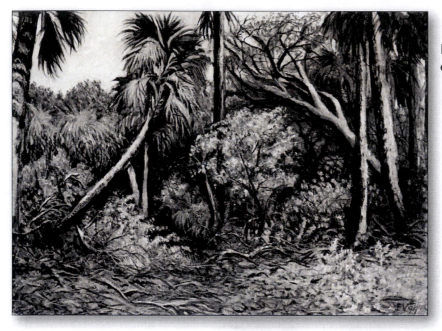

Black-white copy of the
original painting.

The black-white copy
modifications.

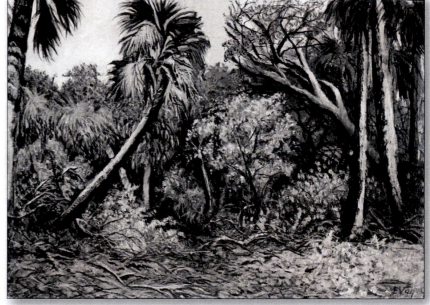

To reshape the original,
use a black-white copy of
the original painting. I begin
the analysis by noticing how
shape positions affect figu-
rative and abstract design.

In the top left picture,
below the trunk of the tiled
palm, two linear shapes represent two small palm trunks forming a V shape.They're
awkward and spatially ambiguous. The position of the smaller palms to the large
tilted is unclear.

The vertical line in the middle of the top edge representing a tall palm, divides
the rectangle picture plane into two uninteresting equal halves.

The picture on the right shows the modification. I've adjusted the trunk lines
helping to clarify the small palms position, and removed the dividing middle line
representing a tall palm.

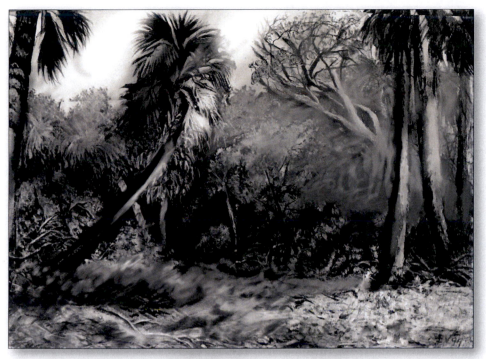

The Reshaped original.

The Reshaped original value design.

Using the five-value design as a guide, I continue to re-shape the original to resemble the large shapes of the value design. Notice how the value simplification helps distinguish spatial planes in the landscape, the foreground, the vertical of the trees in the midground, the distance, and the sky.

The picture on the right is the value design of the reshaped original. It resembles the value design of the original but is more congruent with the modifications.

5) Consider the Compositional Structure, Including the Color.

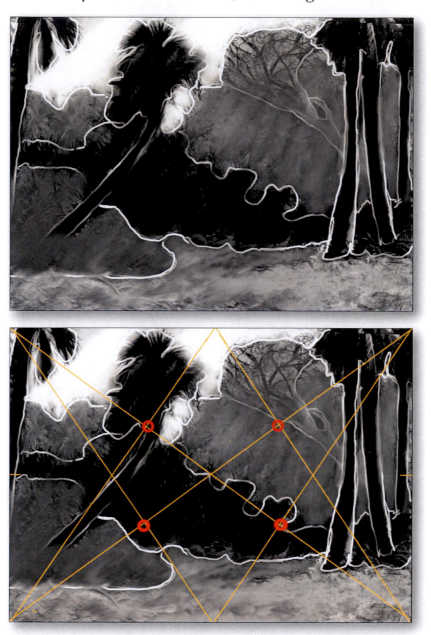

Composition isn't something one does and then moves on to the next step. We are composing the moment one considers the size and proportions of the painting's format to the last paint stroke. Anything done to the image affects the configuration of the representational and abstract content. Therefore, we're constantly composing.

Undoubtedly, most composing occurs unconsciously. Since our goal is to maximize its effectiveness in helping to invent a picture, it's valuable to concentrate and consciously notice the composition. Becoming conscious of the underlying abstract visual elements and their dynamic interactions empowers us to direct the configurations to suit our visual goals.

A detailed account of composition is beyond the scope of this book. I've included a brief summary to give the reader a sense of my thoughts when planning my studio paintings.

In the left picture above, we see the image's **significant shapes.** The shape of the sky with its white value relates it to the next lightest value shape of the ground. A linear shape, representing the left slightly sloped palm emerging from the left border, is balanced by three vertical shapes, meaning three palm trees that appear from the right edge—acting as a bridge, a horizontal black shape representing vegetation connects these shape. A sloping linear form, with a square black shape on top and a small white highlight shape to the right, represents a large tilted palm tree. It sustains our attention briefly before we notice it's part of the long black shape. Two middle-tone gray shapes seem to relate, the triangular shape at the base of the sloping linear form representing the palm and the square shape on the right describing the background. A small gray shape on the left constricted between the white sky and the black shape relates visually with the two middle gray areas just mentioned.

The eye seems to move in a grid-like fashion, directed by the overlap of shapes. But a circular moment presents as the vision follows the path of the long black bridge-like form from the right edge to the left, commencing at the small highlight white shape on the sizeable tilted palm, but quickly redirected away following the direction of the black form to three palms at the right edge, and after promptly jumping to the left edge stopping briefly at the small tilted palm, finally cycling back to start the revelry again at the white highlight shape.

Drawn over the right picture above are diagonal lines called the **Armature of the Rectangle.** These lines cross through the center and at various points dividing the picture plane into ratios of 1/2, 2/3, and 3/4.[25]

At the intersections of the lines shown by red circles are **golden mean proportions,** a ratio of the minor part to the whole in multiples of 1.618.[26] They indicate areas near where centers of attention can be placed and expected to work well.[27] The diagonals further indicate the most prominent movement of the eyes. It is an ancient system, probably invented by the Greeks.[28]Together with gestalt shape-value analysis, it forms a powerful partnership in composition.

Color is an essential aspect of the composition. A Green-Red **split complementary** color relationship appears to fit the colors seen in the subject.

The Green-Red split complementary color relationship. Green to Violet- Red and Red-Orange. Yellow, Yellow

-Orange, and Blue are not part of the split complementary relationship but are close neighboring colors.

Hammock color structure

A) Spectral palette : G/R

B) Chromatic balance: YO/ VR

C) Color hierarchy:
 Dominant : G
 Subdominant: RO
 Submediant: VR
 Minors: B, BG, YO

D) Color map :
 Foreground: R, RO, YO,VR, BV, G
 Middle ground: G, BG,VR,YG
 Background: VR, B, BG

The picture is predominantly green (the Dominant color) in various cool and warm variations of different values. Close behind are abundant red-orange hues (Subdominant color). Of lesser amount is violet-red (Submediant color). There is less blue, yellow, yellow-orange, and yellow-green (Minor colors).

I create a diagram listing the color relationships and their function in the painting and determine each step in the order listed.

A) **The Spectral palette i**s the split complimentary relationship between Green to Orange-Red and Violet-Red.

B) **The chromatic balance** is the warm-cool light alteration, warm Yellow-Orange light, and cool Violate-Red shadows.

C) **The Color Hierarchy** orders colors by their abundance and distribution in the painting. Borrowing terms from music, I label the colors in the order of the most abundant to the least: Dominant color green (G), subdominant red-orange (RO), submediant violate-red (VR), and minor colors blue (B), yellow-orange (YO), Yellow-Green (YG), and Yellow (Y).

D) **The Color Map** is the color position. I've indicated the possible place of the colors: in the foreground, midground, or background.

Using a digital perspective grid, I evaluate the linear perspective. I'm checking if the outlines of forms suggest convergence to vanishing points in the **horizon**.

In this painting, there's one vanishing point in the horizon, shown as a red line, located on the lower left quadrant and coincides with a golden means proportional point of the Armature of the Rectangle.

The Perspective Grid

6) Transfer the Design.

Unlike the definitive outline in the Classical approach transferred using tracing paper, in Realism, as in Naturalism, the contour changes as the painting develops; therefore, it's only necessary to approximate the outline of the value shapes. A free-hand transfer by looking is usually all that's required. For a more definitive transfer, use tracing paper like the classic approach; alternatively, a grid made over a copy of the value drawing and a similar grid on the panel will help reproduce the value drawing. The grid enables the drawing enlargement by drawing the grid larger on the board but with the same proportions as the smaller one.

Like in the Classic approach, ink the values. This step is optional, but the ink helps establish the range of the significant large-value shapes.

A grid drawn over a copy of the value drawing helps transfer it proportionally to a larger panel.

As in the value drawing, a larger grid in the same proportions helps transfer the design. Inking the values is optional, but it helps to create the painting's values.

7) Gather visual facts on the Subject.

I'm using the information found in the plein air painting for this work. There's an abundance of textures and illusions of objects, and I feel confident in their accuracy. However, I'll need a model to determine the angulation of cast shadows in the foreground. That feature I remember is present in the scene but unclear in the plein air work.

On the model pictured below on the right, notice the light direction. We see the long cast shadows of afternoon light. The light falls strongest on the form coinciding with the white shape in the value design representing the highlight on the tilted palm's crown, the primary point of interest.

The light illuminates the form describing the foliage at the base of the tilted palm, a second point of interest, and the position of the vanishing point. I'll use this information when painting the picture.

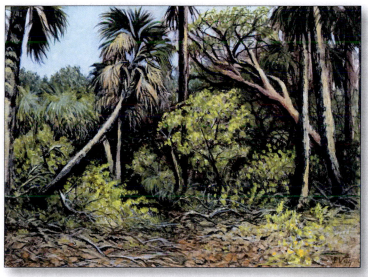

Enough form and textural information are present in the Naturalistic Plein air painting as a reference for the Realistic studio painting.

Clay and paper model of the foreground tilted palm, the foliage at its base, and the right side vertical palms.

8) *Paint the Picture.*

Before beginning to paint, it's instructive to notice what changes might improve the quality of the visual ideas expressed in the initial plein air work. Still, at the same time, it's essential to retain vital ideas.

In keeping with the dense textural details of the plein air painting, I'll uphold the textures as necessary in the studio work. Nevertheless, a problem with the plein air work is the unwanted appearance of shallow space, perhaps partly resulting from the abundance of texture flattening the picture and destroying the illusion of deep space. One solution is to allow the textures to express the surfaces of forms and to help create the illusion of three dimensions by contrasting heavy areas of textures in the foreground with gradually less textured areas towards the lighter values representing the background.

Since deep space illusion is a goal, a better allocation of points of interest is of particular concern since that is mostly lacking in the plein air work with its flat, even distributed appearance. The value design presently identifies the principal interest point on the crown of the tilted palm, but additional attention-grabbing forms must emerge at the golden ratio intersections. If successful, focusing areas will move the eye through the spatial field in two dimensions and into the three-dimensional deep space illusion.

The painting, similarly to the plain air work, is to be predominately painterly, with irregular brush strokes and diffused contours, to express the indeterminacy of time and light.

The first color is dark yellow and white over the ink drawing, similar to the color used in the Classical and Naturalist methods.

Referring to the plein air painting, forms, and textures are created. Nothing is copied exactly from the reference; instead, the purpose is to observe the paint marks character in the plein air painting to express imagined forms similarly. Another way to explain the reference use is by saying the vocabulary of the picture is the paint marks found in the plein air painting. This approach permits the freedom to change the content of the work intuitively.

Besides the plein air painting, the reshaped original, the armature of the rectangle, and the model guide development of the painting's monochromatic underdrawing. The extent of the drawing's detail depends on the subject and goal of the work and is not predetermined.

The ink value design.

The neutral yellow monochromatic layer is the first application over the ink

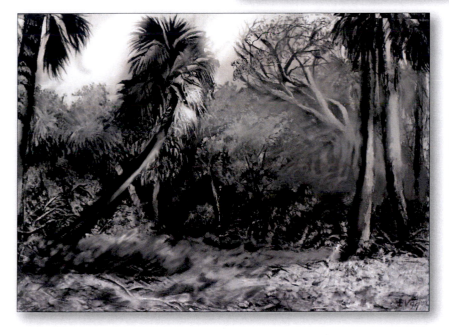

The reshaped original functions as though it's a plein air reference painting but as an imaginary preliminary resembling the one made from life.

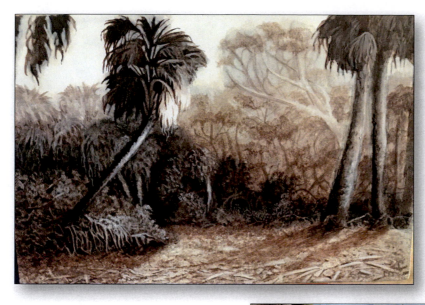

Dark yellow color and white create the monochromatic underdrawing.

The plein air original supplies the vocabulary of the picture in the character of marks it contains.

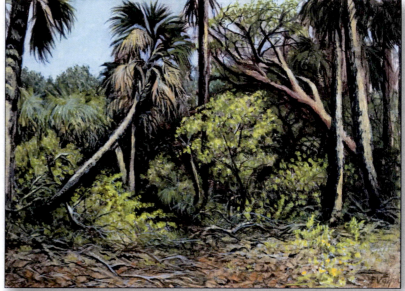

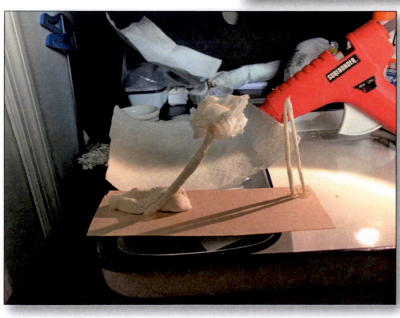

The model transforms two-dimensional shapes into three-dimensional forms, used to observe foreshortening and how form intercepts light, creating highlights, shade, and cast shadows.

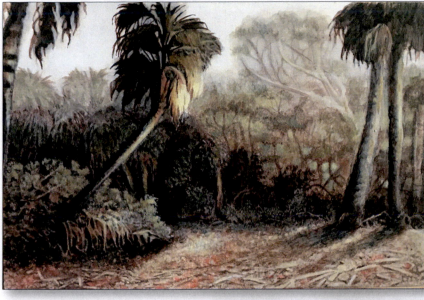

The dominant color, green, is applied first. The yellow underlayer actively interacts with subsequent colors enabling optical modulations.

The subdominant color red-orange is applied, especially in the foreground helping create depth by contrast with the receding green. Note the submediant violet-red in the cast shadows. Yellow-green, a minor color, is vital in moving the eye back to the third point of interest in the middle ground

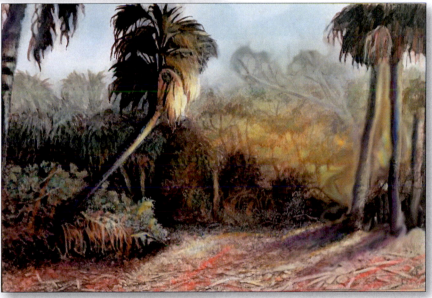

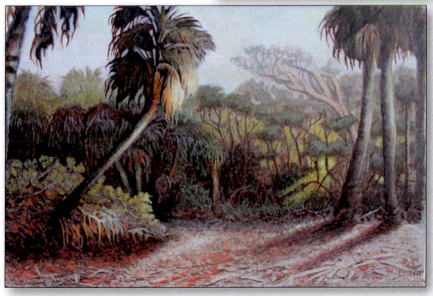

The completed picture is an amalgamation of objective facts and imagination

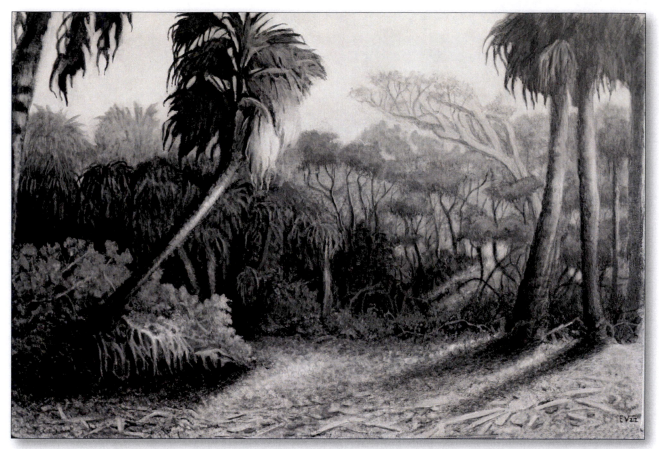

Black & White copy of the finished painting. Compare the completed work to the value study and the Golden Means points of interest below. The value structure is similar. Notice the highlight on the large tilted palm as the main point of interest and the lighted texture foliage below as a second interest point. The third point is the light streaming through the small trees in the middle ground concomitant with the afternoon shadow near it in the foreground, and the fourth is the large light-value tree in the background. The eye moves from the top left half to the bottom, to the right, backward through the midground to the distance, and returns to the top left in an elliptical-like path.

Value Study.

Armature of the Rectangle showing Golden Means proportions points of interest.

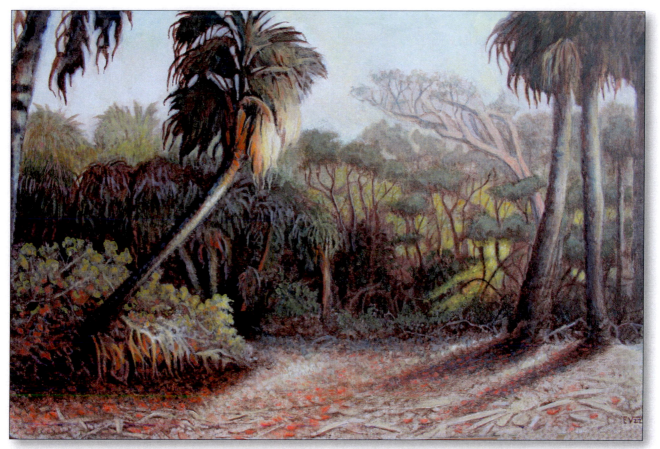

Maritime Hammock . Studio Painting Egg tempera on Hardboard primed with chalk ground, 8″ x 12″.

In this work, the representations and the visual element interactions combine and evoke ineffable characteristics. They're the painting's expression.

At the scene, I experienced a feeling of desolation, a bit frightening, but at the same time, a stately ancient beauty. On seeing the painting, many people commented similar feelings.

They call the landscape old or lonely. One said, "It looks prehistoric, like a landscape at the beginning of the world." Another one called the painting "The Garden of Eden." Another said, "It's beautiful but lonely." Perhaps it's the way the trees look or the direction of light. Maybe it's the color or the absence of people. Who knows. But the quality of an old, lonely, beautiful place seems to be sensed.

This visual potential of communicating human experiences with their association of feelings and concepts transforms paintings into art. At this point, I comment on one aspect briefly mentioned earlier.

The maintained concentration exerted while drawing and painting is similar to meditation. Meditation can result in losing a sense of separateness between the experiencer and the experience, often involving focused attention and heightened awareness. It's especially true of direct egg tempera painting. As a naturalist-realist painter, I'll end the book with a statement expressing the meditative quality of this aesthetic:

Observe the actuality objectively. Rest the attention in the silence of the visual field where there are no emotional afflictions to cause disfiguring preconceptions. As perceptions gradually manifest, surprising patterns emerge almost like magic, and the world appears as though seen for the first time.

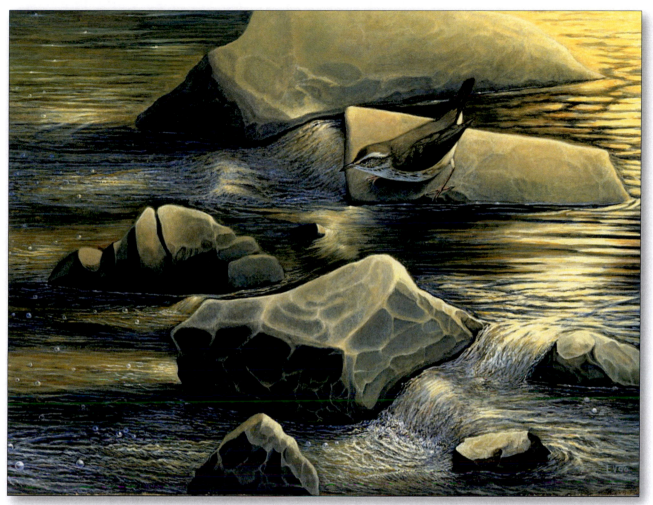

The Risk Taker. Studio Painting. Egg Tempera on Hardboard primed with chalk ground, 10" x 12".

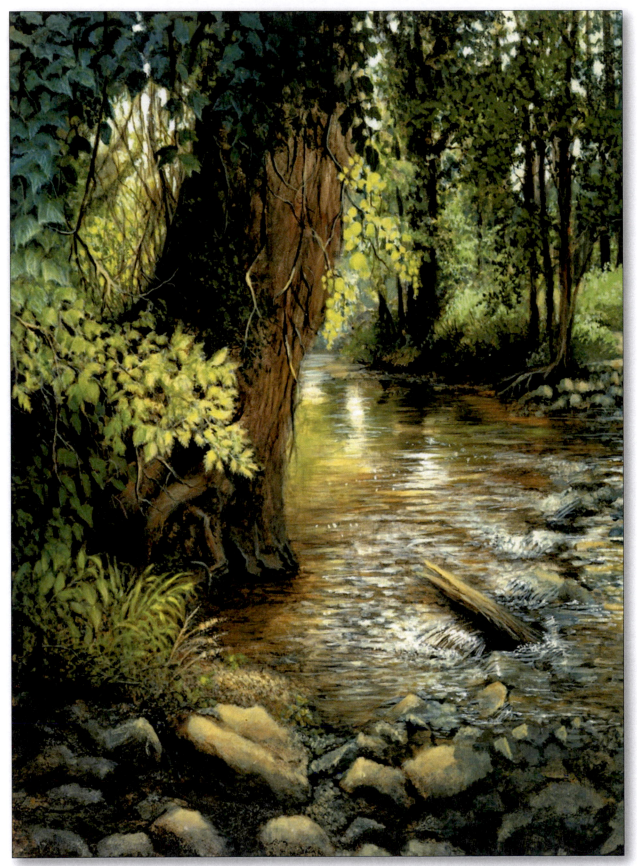

Ellanor C. Lawrence Park. Plein Air painting. Egg Tempera on Hardboard primed with chalk ground, 9″ x 12″.

Glossary

Abstract. The term "abstract" denotes something conceptual, non-specific, and detached from concrete reality, often emphasizing broader ideas, principles, or aesthetics. In representational art, abstract signifies the underlying shape actuality and their dynamic visual interactions apart from whatever illusions these shapes evoke. The abstraction is an alternative interpretation of the illusion, like a reciprocal of the representation. Both readings are essential for compositional comprehension and for understanding the representations.

Acrylic gesso. Acrylic gesso is a type of primer comprising several components, including a binder, pigment, and additives. The binder is typically an acrylic polymer. It's soluble in water only when wet but becomes impermeable to it when dry. It permits the egg tempera paint to adhere physically by mechanical retention but not chemically by absorption. Recently a new absorbent acrylic, Rublev Tempera Ground, is sufficient for most egg tempera paintings, although not as absorbent as chalk gesso.

Actuality In image making, it refers to the analytical aspects of a subject observed empirically, such as edges, shapes, alignments, directions, positions of forms, degree of illumination, textures, and to a lesser extent, color.

Actuality of the picture plane. The physical two-dimensional surface that a painting consists of. The concept recognizes that a painting or any two-dimensional artwork exists as a surface with its physical properties and limitations. Understanding this reality, a painter considers the dimensions, shape, and orientation and how the elements within the artwork relate to that surface. This consideration influences how the artist arranges and organizes the visual elements, such as lines, shapes, colors, and textures, within the boundaries of the picture plane.

Aesthetics. Aesthetics is a broad and multidisciplinary field encompassing philosophy, psychology, sociology, art history, and cultural studies. It offers a framework for understanding and evaluating art, beauty, and their role in human perception

and experience. Aesthetics examines the nature of art and artistic expression. It explores the definition of art, the purpose of artistic creation, and the relationship between art and beauty. When an artist pursues one aesthetics, it means they intentionally explore and express a particular set of principles, ideas, or concepts related to beauty, art, and the nature of their artistic practice, and often develop a personal or unique vision.

Ala prima. An Italian term that translates to "at first attempt" or "at first go" in English. In painting, ala prima refers to a technique where the artist completes a painting in one session, typically in a single sitting. It is also known as the "direct painting" or "wet-on-wet" technique.

With ala prima painting, the artist works quickly and spontaneously, applying wet paint onto a still-wet surface. This approach contrasts with traditional layering techniques, where artists build up layers of paint, allowing each layer to dry before applying the next. First used in the 17th century by a few artists in the Dutch Golden Age, it blossomed in the 19th century with the invention of tube paint.

Alkyd. Alkyd resins are synthetics from the reaction of drying oil, such as linseed or soybean oil, with a polyhydric alcohol, such as glycerol or pentaerythritol. This chemical reaction creates a durable and glossy film when the paint dries. They also dry relatively quickly, usually within 24 hours, and produce a hard, durable finish that resists cracking and yellowing over time. Liquin is a popular alkyd medium formulated explicitly by Winsor & Newton. Liquin is used in the egg tempera-oil mixed technique to make an thin resin film for drawing into with egg tempera paint. Add it to a yolk-oil emulsion to increase the refractive index and facilitate glazing.

Analogous It refers to a relationship or comparison between items or concepts with a likeness or resemblance, though they may not be identical. In color theory, analogous colors are hues adjacent to each other on the color wheel.

Animal Glue Also known as hide glue or protein glue, it's an adhesive made from animal collagen, primarily derived from the connective tissues and bones of animals such as cattle, horses, and rabbits. It's commonly referred to as size when dissolved in water, but technically the word size means a thin layer of glue. Gelatin is also an animal glue but a less strong collagen product.

Approximate and generally In drawing and painting, approximate, as opposed to specific, signifies all shapes do not have maximum correspondence with a subject's objective aspects. The term generally implies that part or all of the representation only suggests, instead of exactly, depicting the subject.

Archival Using materials and techniques that helps mitigate risks and prolong the lifespan of valuable items, enhancing their long-term preservation. Egg tempera is a highly archival medium.

Armature of the rectangle For centuries, the artist drew diagonals in rectangles to divide them into harmonious proportions, such as half, third, and fourths. Highly sought is the golden mean proportion situated at the thirds and dividing small to the larger areas by multiples of 1. 618. These locations frequently are used to situate essential elements in the picture. The directions and angles of rectangles and the resulting subdivisions help the artist to position representations in a harmonious dynamic relationship. The term armature of the rectangle was coined by Charles Bouleau in his book on composition "The Painter's Secret Geometry" in 1963.

Balance In perception, balance is an experience of equality of attraction between two or more visual elements resulting in a resolution of dissimilarity of interest that fixates attention,

Calcium Carbonate It is a common substance found in rocks worldwide and is the main component of shells of marine organisms, snails, pearls, and eggshells. Calcium carbonate is the principal mineral in limestone, chalk, gypsum. and marble. Chalk is a soft, porous, sedimentary rock primarily composed of calcium carbonate. It is often found in areas with deposits of marine organisms.

Cartoon In Renaissance art, cartoon referred to a detailed composition outline to transfer the design to the panel.

Chalk ground It is also known as a gesso ground, and it involves applying a layer of powdered chalk or gypsum mixed with a binder, such as animal skin glue, to a rigid support, typically a wooden panel. Applying chalk ground creates a smooth, absorbent surface that provides a foundation for the subsequent paint layers. The chalk ground helps to generate a surface that allows the egg tempera paint to adhere physically and chemically tenaciously.

Chromatic balance The chromatic balance is the color contrast between areas painted to depict the light and those representing the shadows. In landscape, it results from two light sources: the sun's warm yellow and the sky's cool blue. The illuminated is said to be warm, and the shadows cool. Indoors the opposite is true. The blue light from a window makes the illuminated cool, and the shadows warm from a secondary inside light source. Chromatic balance is essential to create depth, atmosphere, and visual interest and enhance the sense of illumination.

Classical Tempera Method (CTM) It is the process used by the Renaissance tempera painters. The sequence of steps, each completed before the next, achieves a predictable outcome systematically. These steps are Exploratory, Modello, Underdrawing, and Painting. It's of ancient origin, possibly used by the Greeks imported to Italy in the 12th century from the Byzantium. With many modifications, the method forms the foundation for European painting until the mid-19th century. Its success likely stems from the division of labor between form drawing and the application of color.

Classicism Classical art is known for its emphasis on balance, harmony, rational proportions, and idealized representations. It aims to achieve perfection, order, and beauty through careful attention to excellent craft, symmetry, balanced compositions, and ideal forms. The classic artist seeks a reality that can transcend deformation and change. In painting, the classical approach expounds graceful contour lines, clearly defined edges, restraint, and moderation of color and predominantly uses light and shade to clarify volumes.

Color design Color design refers to the intentional selection and arrangement of colors. It involves choosing colors that harmonize and communicate a desired message or evoke specific emotions. Color design considers the relationships between colors, contrast, saturation, brightness, and overall composition to create visually appealing and meaningful designs. Color schemes refer to the combinations of colors chosen for a design, such as monochromatic (using shades and tints of a single color), complementary (using colors opposite each other on the color wheel), analogous (using colors adjacent to each other on the color wheel), or triadic (using three equally spaced colors on the color wheel).

Composition The study of how an image's abstract visual components and illusions evoke are ensemble by perceptive responses into an organization possessing unity, contrast, and emotive expression.

Color Hierarchy Repeating several colors throughout is a common way to achieve color harmony in a painting. Still, another way is to make the picture predominantly one color and progressively less of others to create a hierarchy of colors. When using color hierarchy, the colors are named and listed by their abundance in the painting from the most to the least: the dominant color, the subdominant, the submediant, and minor color.

Color map The color map approximately estimates a color's position in the painting. It can refer to the color's place in the two-dimensional plane or one of the illusionistic three-dimensional planes such as the foreground, midground, or background.

Color wheel Several color wheel associations exist. The most common and valuable for painters is the Newton wheel, made of 24 colors. It relates the primary colors, secondaries, and tertiary colors to each other.

Congruent Congruent, as used in painting, describes a comparison between two or more identical shapes. When two shapes are exactly congruent, all corresponding sides and angles are equal. In other words, if you superimpose one shape onto the other, they would completely coincide.

Conscious and deliberate In painting and drawing, conscious and deliberate signifies a rational cognitive decision to include or exclude, add or remove, modify, and organize the visual elements.

Complementary colors Colors opposite in the color wheel are called complementary. When mixed in unequal quantities, their hue neutralizes and becomes low-intensity gray colors. Equal amounts of both colors will create gray.

Correspondence In painting and drawing, correspondence compares the shapes, measurements, and relationships between the representation and a subject. The correspondence's extent determines the congruency or similarity between a drawing or painting and the subject. It establishes a connection between the drawing or painting and the corresponding parts, such as the subject's vertices,

sides, angles, or other features. A one-to-one correspondence of subject and representation achieves exact congruency.

Direct Refers to paint or draw a picture positioned in front of the subject. The work becomes a subject if a prior two-dimensional work, such as a photo, is used.

Direct Tempera Method (DTM) Refers to the technical and perceptive process of using egg tempera to paint a direct picture.

Dispersion. The distribution of particles of one material through an area of another.

Drawing-Painting Cycle The Drawing-Painting cycle refers to the continuous and iterative process through which the artist perceives the subject, compares it to the developing work, notices discrepancies, and changes the work to increase the correspondence with the subject . The artist's changes in the piece result in a new preconception of how the subject appears to the mind. The feedback is received by the artist's visual systems, initiating a new cycle of perception and response. It is a fundamental concept in creating a Naturalistic image.

Dynamic relationships In the context of drawing and painting are the optical associations of attraction or the repulsion between two or more visual elements. The relationships direct vision through the work like an optic force.

Dry ounce A dry ounce is the amount of any dry substance weighing the same amount as water in one fluid ounce. One dry ounce = 28.3495 grams, or rounding off to 28.0 g, is the weight of water found in one fluid ounce.

Drying oil Oils from plant sources exposed to air undergo a polymerization reaction that hardens them to a solid film. The most common drying oil is linseed oil. Other examples of drying oils include tung, walnut, poppy seed, and safflower.

Egg Tempera Color pigment particles tempered (mixed) with the yolk of an egg. Yolk contains water, triglycerides (egg oil) dispersed in the water and prevented from coalescing and separating by phospholipids (notably lecithin and cholesterol) plus proteins to form an emulsion known as an oil-water emulsion, giving the medium unique quality.

Emulsifiers Emulsifiers are molecules with both a water-attracting (hydrophilic) and oil-attracting (lipophilic) portion. They keep the components of emulsions

in a continuous phase preventing them from coalescing and coagulating. The phospholipid Lecithin is the most important in the egg yolk.

Emulsion An emulsion is a mixture of two or more immiscible substances, such as oil and water, in which one substance in tiny droplets disperses in the other.

Expression It's the subjective, emotional evocation an image appears to project to the viewer

Five deterrents The five detergents are five questions to ask about the conditions present that help to decide, before setting up, if it's possible to paint a subject directly.

Five value shapes The paint can't imitate nature's value range. Painters learn to manage this limitation by restricting the extensive value range perceived in vision. It is an organizational strategy enabling the realization of the appearance of illumination into a manageable number of values. The values restrictions vary, usually between 3 to 5, and it's at the painter's discretion.

Fundamental size- gesso ratios These are the most common recipe ratios for preparing the size and chalk gesso. The size is one part, by weight, animal product: 16 parts water. The gesso is one part, by volume, size: 1.5 chalk.

Gelatin It's an animal collagen product available as Knox gelatin in supermarkets, suitable for making size. An adhesive made from animal skins and bones, it's considered less intense in binding than the animal collagen product made from hide and tendons called hide glue.

Gesso It is mostly Calcium Carbonate, chalk mixed with animal or synthetic polymer glue. Other components are marble dust and titanium white. Magnesium carbonate can replace Calcium as the main ingredient. They're all products of limestone sedimentary rocks.

Gestalt In art refers to a concept that emphasizes the holistic perception and organization of visual information. It represents the idea that the whole is more than the sum of its parts. It emphasizes the interrelationships between visual elements. The concept of gestalt has significantly influenced art and design, highlighting the importance of considering the overall configuration and structure in understanding perception and cognition. Direct painting relies more on gestalt perceptions than a conscious and deliberate process.

Glaze Generally, a glaze is a transparent color over another, usually a more opaque color. In egg tempera painting, a glaze has a specific meaning: it consists of a darker color painted over a lighter one, resulting in a warming intensifying effect of the lower color. It's the opposite is a scumble.

golden mean proportions It's a ratio of the minor part to the whole in multiples of 1.618. Within a parallelogram, the intersection of 4 perpendiculars formed by a line drawn from each corner to one of the two significant diagonals creates 4 points at 1/3 decisions. Connecting two of the four points, horizontally or vertically, divides the parallelogram into two in golden mean proportions. The interception points at 1/3 deviations indicate areas near where centers of attention work well.

Grassa Grasas is an oil-yolk emulsion made by adding drying oil to the yolk-water emulsion. The additional oil modifies the yolk-water emulsion, but the mixture remains soluble in water.

Horizon In linear perspective, the horizon is a horizontal line at the eye level of the observant. The horizon line often plays a crucial role in establishing perspective and creating a sense of depth. It serves as a guide for determining the vanishing points and the convergence of parallel lines, helping to depict the spatial relationships between objects and the viewer.

Hue Hue is one of the three primary attributes of color, along with saturation and value. It is the quality that allows us to differentiate between different colors.

Ideal preconceptions In connection with art, it refers to concepts and attributes a subject or work must posses for attaining quality.

Illusionistic Illusionism, in the art context, refers to a style or technique that aims to create the illusion of three-dimensional space or objects on a two-dimensional surface. It uses various visual strategies and techniques to deceive the viewer's perception and make sense of depth, volume, and texture.

Impasto In painting, impasto refers to applying thick layers of paint onto a surface, creating a textured and three-dimensional effect.

Indirect Indirect means working away from the subject. It's the opposite of direct painting or drawing before a subject. Layering techniques are associated with indirect painting.

Inner-directed When an artist's primary goal is expressing conceptual or emotional experiences, it's said to be inner-directed.

Interpretive analogy It involves creating visual representations that are not literal or altogether portraits of the subject matter but surveys expressing approximate and general qualities or connections.

Language of Paint The "language of paint" refers to the visual elements and techniques painters use to communicate perceptions, ideas, emotions, and aesthetics through a painting medium. It encompasses various aspects of painting, such as color, texture, brushwork, composition, and application methods. Painters use these elements intentionally to convey their artistic vision and engage viewers on multiple levels.

Layer In painting, a layer is a dry paint film distinct from any subsequent paint applied over it.

Limited palette It's a set of a few restrictive colors used to paint.

Linearity Linearity, in general, refers to the use of lines. However, a distinct outline bounding the edge or contour of shapes representing a subject functions similarly to a line. Classical aesthetics is often associated with linearity, where the precision and absolute sense obtained by it gives a feeling of clarity and order.

Linear perspective Linear perspective is a technique used in two dimensional art to create an illusion of depth and three-dimensionality on a two-dimensional surface. The concept is that parallel lines appear to converge as they recede into the distance, eventually meeting at a vanishing point on the horizon line. Most painters use it intuitively except when representing architectural subjects.

Local color It's an object's surface color appearance in even colorless light without chromatic color illumination.

Lost and Found Edges In painting, lost and found edges create a sense of depth, atmosphere, and visual interest by manipulating the clarity of the boundaries between different objects or areas within a painting. A " lost edge" creates ambiguity and obscurity and can suggest areas of transition, atmospheric effects, or objects merging into their background. On the other hand, a "found edge" is a clear, defined, or sharp boundary. These edges are more visually pronounced

and often draw attention to specific areas of interest. The technique is vital to the naturalistic aesthetic.

Metal point One of several metal rods sharpened to a fine point for drawing on a prepared, lightly rough surface. The most common metals are silver and gold.

Mixed Technique The method consists of drawing with prepared yolk-oil emulsion or simply with the yolk-water emulsion paint, using a small round brush, into a thinly applied resinous oil coating or oil glaze. Liquin mixed with oil paint forms an effective glaze. The color used to draw is usually opaque white. Within seconds, a new color glaze over the drawing is possible. One draws with egg tempera and colors with alkyd oil—a high degree of microscopic detail results.

Modello During the Renaissance, the artists created detailed preliminary drawings, the modello, to demonstrate their ideas to clients and help guide the work.

Modified part approach It is a painting method that fully completes parts of a painting but not in a linear sequence. Instead, it alternates the completion of sections throughout the picture. It permits a more holistic assessment of dynamic relationships.

Monochromatic Underpainting It is the first layer of paint applied to a painting made only of a single color expressing the value configuration and frequently refined sufficiently with white to render the form of the subject. The color contrasts with the upper layer. In the Renaissance, this layer was greenish, or Verdacio, differing from the pinkish skin color. In practice, it can be any neutral color.

Naturalism In drawing and painting, naturalism intents to represent reality as it appears to the human mind. Reality is inimitable, however, since no medium can imitate brain cellular activity. Therefore, all representations are degrees of approximations. The artist begins with an approximation, a schematic, and compares it with the subject, followed by a modification to increase the correspondence with the subject. A new observation continues followed by further modifications. This cycle persists until a good congruity emerges.

Neutrals colors Neutrals are colors of low intensity..

Opaque A paint film impervious to light. It's one of three phases of the egg tempera paint. Translucent and transparent are the other two.

Optical Blending It is the technical skill in painting or drawing of creating a smooth transition from one color or value to another by juxtaposing closely alike colors or values to generate the illusion of physical blending. It's fundamental in egg tempera painting.

Optical Gray Modeling It's a modeling technique using various amounts of single-color paint and the color of the ground to create different values. It's mainly for making the underdrawing.

Outer-Directed When an artist's primary goal is expressing observable or factual experience, it's said to be outer-directed.

Painterly A work is said to be painterly when the contour of shapes is ambiguous; there's the abundant use of lost and found lines, and the depiction of light and atmosphere, movement, or emotional experience is a central goal. Frequently, brush strokes remain visible and function as a unifying aspect of the design. It's the opposite of linearity.

Perception Visual perception is a neurological phenomenon beginning in the retina, encoding light into electrochemical impulses transmitted to the thalamus and occipital lobes, then to the frontal lobes, where the interpreted signals convert into images and concepts. Our perceptions shape our understanding of reality and influence our thoughts, emotions, and behaviors.

Pigment Paste It's the color powder pigments mixed with water.

Planes of Space It refers to the three illusionistic space locations in a two-dimensional surface: the foreground, the mid-ground, and the background.

Platonic Perfection It refers to the concept of idealized and flawless beauty or form. Plato believed that artists should strive to depict or represent these ideal forms rather than the imperfect physical reality. Platonic perfection in art emphasizes harmony, proportion, and balance in describing beauty. It often involves idealization.

Realism Used interchangeably with naturalism, realism differs in two ways. It attempts to represent scenes or events that are absent and, therefore, unobservable, and it frequently restructures what exists to emphasize a dynamic composition. The goal is to paint the imagined as though created from life. It uses the facts obtained by naturalist inquiry to imbue the work with reality.

Reciprocal shape-illusion The term emphasizes the inseparable relationship between two-dimensional reality and representational illusion. In representational work, the illusions are shape constructions; the shape and the illusions are reciprocals.

Refractive idex The refractive index measures how much light is bent or refracted as it passes through a medium. Pictures painted with mediums with lower index surrounding pigments with higher indexes appear lighter and less color saturated.

Resin Varnish It's a protective coating applied over a finished drawing or painting. It contains a high concentration of synthetic or natural resins responsible for forming a hard, durable film when the varnish dries. The primary purpose of applying resin varnish is to protect the underlying artwork from various environmental factors. Resin varnishes come in different formulations, including acrylic-based and oil-based variants. It can add a glossy or satin finish, intensify colors, and provide depth to the artwork.

Salient Points When painting or drawing, they are prominent marks important in accessing spacial relationships. Most notably, they help determine the position of new marks when making optical corrections.

Saturation It's the intensity of a color. One of three aspects of color, the other two being value and hue.

Schematic At the start of a drawing or painting, it's the initial visual assumption of the subject's appearance.

Scumbling It consists of applying a thin translucent layer of paint over a dry layer. The scumbled layer is lighter in value than the underlying layer, allowing the colors and textures of the lower layer to show through. In egg tempera painting is a light color over a dark.

sgraffito The technique of scratching out the paint with a pointed tool,

Significant Shapes They are shapes, usually more extensive and mid-size, that create the illusion of a subject. In addition to creating an illustration, these shapes must form an interesting abstract configuration.

Specific and exact In drawing and painting, specific, as opposed to approximate, signifies all shapes have maximum correspondence with a subject's objective

aspects. The term generally implies that all of the representation precisely depicts the subject.

Spectral Palette It refers to the conceptual combinations of colors chosen for a design instead of the actual pigments used. Such as monochromatic (using shades and tints of a single color), complementary (using colors opposite each other on the color wheel), analogous (using colors adjacent to each other on the color wheel), or triadic (using three equally spaced colors on the color wheel).

Split complementary colors In the color wheel, the split complementaries are the two neighboring colors on either side of a color's complementary.

Structure Structural organization refers to the significant ordering of the visual elements in a drawing or painting. The configuration provides aesthetic and expressive relationships that unify and enhance the work's visual goal.

Surfactant Also known as a wetting medium, a surfactant reduces the surface tension of water, allowing it to spread more rapidly and evenly across a surface. The wetting agent can help the egg tempera blend by slightly extending the working time.

Tempera-Inlay Tempera-inlay refers to the mixed technique embedded egg tempera or grassa paint inside the resin or alkyd oil glaze.

Thin-Dense Paint Egg tempera can behave more like watercolor or oil depending on the amount of water added to the yolk. Make thin-dense paint by adding a small amount of water to the yolk when preparing the yolk-water emulsion and by wiping the brush almost dry before painting. The paint film behaves like thin fast-drying oil paint.

Three dimensional model It's a model made of simple materials such as clay and paper to discover how light and shade appear as the illumination intersects forms and the foreshortening appearance of space.

Tone Any pure color or mixtures combined with both black and white in different proportions.

Translucent A semi-opaque paint film. One of three natural phases of egg tempera paint. Opaque and transparent are the other two.

Transparent A transparent paint allows light to penetrate and interact with the layers beneath it. It's one of the three natural phases of egg tempera. Opaque and translucent are the other two.

Truth to Nature Truth to Nature is a concept that emerged during the 19th century. It's synonymous with landscape naturalism. Artists who adhere to the principle of Truth to Nature seek to depict landscapes as they appeared in reality, often working directly from observation and plein-air painting. It reflects the artist's appreciation for Nature's inherent qualities and desires to share that experience with the viewer. However, Truth to Nature is not an objective or absolute concept. The representation depends on the artist's perception, interpretation, and personal style.

Underdrawing An underdrawing is a preliminary drawing on the panel preceding the paint application made to guide the work.

Value Value refers to the relative lightness or darkness of a color. It's the range between black and white, with shades of gray in between. Value is essential in creating a sense of depth, form, and volume in two-dimensional work. In the Classical Tempera Method, values form the underdrawing. It's one of the three elements of color, with hue and saturation the other two.

Value design Value design is the aesthetic, depictive, and expressive arrangement of significant value differences in a painting or drawing.

Visual Elements The components or building blocks that artists use to create their work. Artists manipulate these fundamental visual qualities to represent, convey meaning, evoke emotions, and communicate ideas. The elements include Line, Shape, Space, Volume, Value, Color, and Texture.

Visual weight It's the capacity of a visual element or representation to attract attention.

Working Time The time the paint remains fluid before it dries to the touch. The working time of yolk-water emulsion is approximately 2.5 to 3 minutes.

Yolk-Oil-Surfactant Emulsion (YOSE) It's a Yolk-oil emulsion consisting of yolk, water, water-mixible oil, and surfactant in a 1: 1/2: 1/4 ratio, respectively. The advantage is the integration of all components by water solubility—the resulting medium permits egg tempera to mix physically slightly.

Bibliography

Arnheim, Rudolf. Art and Visual Perception: A Psychology of the Creative Eye. California: Berkeley and Los Angels : University of California Press, 1974.

Arnheim, Rudolph. The Power of the Center: A Study of Composition in the Visual Arts. Berkeley and Los Angeles: California University Press, 1988.

Birren, Faber. Creative Color: A Dynamic Approach for Artist and Designers. West Chester Pennsylvania: Shiffer Publishing Ltd, 1987.

Bouleau, Charles. The Painter's Secret Geometry: A Study of Composition in Art. New York: Dover Publications, 2014.

Carlson, F John. Landscape Painting. New York: Dover Publications, 1958.

Clark, Andy. The Experience Machine: How our Minds Predicts and Shape Reality. New York: Pantheon Books, 2023. Kindle.

D'Amelio, Joseph. Perspective Drawing Handbook: Fundamentals of Perspective Clearly Explained. New York: Van Nostrand Reinhold, 1984.

Doerner, Max. The Materials of the Artist and Their Use in Painting: With Notes on the Techiques of the Old Masters. Orlando, Fl: Harcourt Brace Jovanovich, 1977.

Goldstein, Nathan. Design and Composition. New Jersey: Prentice-Hall Inc, 1989.

Goldstein, Nathan. Painting: Visual and Technical Fundamentals. Englewood Cliffs, New Jersey: Prentice-Hall Inc, 1979.

Gombrich, E.H. Art And Illusion: A Study in the Psychology of Pictorial Representation. Princeton, N J: Princeton University Press, 1989.

Hambidge, Jay. The Elements of Dynamic Symmetry. New York: Dover Publications, 1953.

Jacobs, Michel. The Art Of Composition: A Simple Application of Dynamic Symmetry. London: Forgotten Books, 2018.

Jill Dunkerton, Susan Foister, Dillian Gordon, Nicholas Penny: Giotto to Durer Early Renaissance Painting in the National Gallery. London: National Gallery Publications, 1991.

Laurie, A.P. The Painter's Methods and Materials: Traditional Techniques and Materials for Practicing Artists; oil, watercolor, tempera. New York: Dover Publications, 1967.

Mayer, Ralph. The Painter's Craft. New York: Penguin Books, 1991.

Meisner, B Barry. The Golden Ratio: The Devine Beauty of Mathematics. Goldennumber. net: Race Point Publishing, 2018.

Quiller, Stephen. Color Choices: Making Color Sence Out of Color Theory. New York: Watson-Guptill Publications, 1989.

Ross, Denman Waldo. On Painting and Drawing. Boston and New York: Houghton Mifflin Company, 1912

Schadler, Koo. Egg Tempera Painting: A Comprehensive Guide to Painting with Egg Tempera:

Koo Schadler, 2021. Kindle.

Speed, Harold. The Practice and Science of Drawing. New York: Dover Publications, 1972.

Stephenson, Jonathan. The Materials and Techniques of Painting. New York: Thames and Hudson Ltd, 1989.

Streeton, L.W. Noelle. Perspectives on the Painting Techniques of Jan Van Eyck: Beyond the Ghent Alterpeace. London: Archetype Publications Ltd, 2013.

Sultan, Altoon. The Luminous Brush: Painting with Egg Tempera. New York: Watson-Guptill Publications, 1999.

Thompson, Jr. Daniel. The Practice of Tempera Painting: Materials and Methods. New York: Dover Publications, 1962.

Thompson, Jr. Daniel. The Craftsman's Handbook: " Il Libro Dell' Arte" Cennino d' Andrea Cennini. New York: Dover Publications, 1954.

Toney, Anthony. Painting and Drawing: Discover your Own Visual Language. Englewood Cliffs, New Jersey: Prentice-Hall Inc, 1978.

Vickrey, Robert. New Techniques in Egg Tempera. New York: Watson-Guptill Publications, 1973.

Watrous, James. The Craft of Old-Master Drawings. Madison, Wisconsin: The University of Wisconsin Press, 1957.

Wehlte, Kurt. The Materials & Techniques of Painting with a Supplements on Color Theory. New York: Van Nostrand Reinhold Ltd, 1982.

Whitney, W Richard. Painting the Visual Impression. Burnsville, Minnesota: MN River School of Fine Art, 1993.

Wolfflin, Heinrich. Principals Of Art History: The Problem of the Development of Style in Later Art. New York: Dover Publications, 1950.

APPENDIX I
The Well-Temperred Tone Palette

The Well-Tempered Tone Palettes

The Well-Tempered Tone Palette is a predictable, naturalistic, practical color theory. The colors of a Primary Triadic palette (yellow, red, blue) and their mixture of secondaries (orange, green, violet) assemble in 5 values from Dark to Light. They all are harmoniously related by containing gray as the unifying constituent of each color. The tones are modified by overpainting with pure hues or other colors. Each tone is interchangeable, at a specific value in a painting, for any different tone of similar value.

Uniforms Chroma Scales

To understand how to create a Well -Tempered Tone Palette and why it's useful, I'll explain a color gradation called the Uniform Chroma Scale. It was first described in 1916 by Wilhelm Ostwald in his book A Color Primer. I heard about the scales from Faber Birren in his book Creative Color (Barren, 1987, p. 25) when searching for information on a naturalistic color method that would suit the Egg Tempera medium. I wanted to find a way to mix colors predictively to help me paint quickly from life. Because painting from life can be very challenging, finding a concise, extemporaneous way to build a painting is useful. I found the system of complementary color mixing to make neutral grays slow and did not suit me.

Combining complementary colors to mix neutrals requires many colors to create them successfully. The resulting neutrals are almost always unpredictable. By this, I mean that the hue of the grayed color is difficult to anticipate. Although the complement mixing methods are delightful and undeniably beautiful, I found that when using this methods finding the color became the reason for the painting. It consumed the time I had available to paint. The formal and constructive elements in the painting became secondary to the relentless search for the color. I was also searching for the best way to depict light.

I believe color in the painting is not synonymous with light, but instead of color, the light's foremost exponent is the psychological perception of luminosity.

Varied color seems to destroy the perception of luminosity. A wide field of grays is important for the representation of light. A perceptive transformation occurs when a neutral gray surrounds a more saturated color. The color takes on the appearance of light. With this in mind, I searched for past landscape colorists' ways, and I wanted to work with a simple limited palette.

In the book Creative Color, Fiber Birren described the resulting colors of the Uniform Chroma Scales as the best colors to use for naturalistic representation. He

called a tone the mixture of a color with both black and white. It interested me, not only because I had found a simple way to neutralize a color, control value, and chroma, but because, as previously mentioned, white and black pigments, for me, are essential for successful Egg Tempera painting.

To construct a tone, pick any color and mix with it equal amounts of black and white. Alternatively. to create a tone, incorporate the black and white into a gray mixture of any value and mix it with the color. The more gray, the lower the intensity of the color. Mix more white than black to create a light-tone gray, or mix more black than white to create a dark-tone gray, then add the result to the pure color, respectively. Carefully adjust the black, white, and color quantities to refine the desired value and intensity. The components of the tone, regardless of its value or intensity, stay the same. It is straightforward and predictable.

A more useful way to think of the Uniform Chroma Scale is the Tint-tone-Shade scale. It's a tone scale made from a middle tone made lighter by adding greater quantities of white and darker by adding greater amounts of black. It is the same as if a middle tone is created by adding a pure color to a middle-tone gray mixture, then making a lighter and darker value gray mixture and adding them each to the pure color.

As Fiber Birren described, one limitation with this method is that yellow, and to a lesser extent, red, lose their hue identities when mixed with gray. For example, yellow will turn green. Red become a pink and dark maroon. I found a way to correct this problem by inventing The Well-Tempered-Pallete, a system to prevent the loss of yellow and red hue identity. It also allows modifications to a tone by overpainting with a color. The result is a coloring method that has worked very well for me. I've found they can represent any color I see in nature.

The Well-Tempered Tones Palettes

Color has properties that suggest analogies to music. Therefore, I use musical terms to describe my perceptions of color. "The Well-Tempered Tone Palette" comes from Bach's keyboard work The Well-Tempered Clavier. To temper the clavier (a 17th-century Baroque keyboard instrument that predates the pianoforte) meant adjusting the notes in the device to allow the use of all the different scales of music in the same piece. Likewise, I wanted to adjust all my color's value gradations so that another color could quickly and predictably replace each color of my

painting in the palette. If each color in the palette is chromatically connected and simultaneously of equal value to the one it would replace, it's possible. The addition of a common gray uniformly relates all Uniform Chroma Scales. For example, light green could replace light red because they are the same value and contain a unifying element. But one problem remained.

Think of the Uniform Chroma Scales as a Tint- Tone – Shade gradation or scale.

The hues of the colors must not change drastically with the change in values. The solution consists of adding different pigments to the initial mixture used to form the Tint-Tone Scale gradations. These accessory pigments prevent the yellow from turning green and the red from turning pink. In addition, it contains the red from becoming too cool with dark gray. I refer to the initial pigment as the Parent pigment, and the other pigments I named the Auxiliary pigment. The Tint-Tone Scale for red using Cadmium red as a Parent color uses two Auxiliary pigments, Yellow Ochre, and Burt Umber. The modified Tint-Tone Scale now consisted of a mixture of the Parent pigment Cadmium Red Light, Gray, and the Auxiliary pigments of Yellow Ochre and Burnt Umber. The proportions of these pigments vary as the scale modulates from light to dark, but the component of the mixture is constant. The grays

are always mixed exclusively with Titanium White and Mars Black. These pigments are opaque. I created a similar combination for my yellow Tint-Tone-Shade Scale. The Parent pigment is Cadmium Yellow Light and the Auxiliary pigments of Yellow Ochre and Burt Umber. Both warm colors contain the same Auxiliary pigments, and both Parent colors are Cadmium based. As a result, the Tint-Tone-Scales of red and yellow are highly related and unified. They varied only in the Parent color. Not every color needs Auxiliary pigments to maintain the parent color's hue identity. For example, the Tint-Tone Scale for the pigment Prussian Blue doesn't need Auxiliaries. Its high tinting strength assures that light or dark gray additions to the initial, pure blue do not lose the blue hue.

Mix the primary tones to create the secondary tone colors of orange and violet. For example, the light red Tone and the light-yellow Tone create the light orange Tone. Instead of mixing the secondary green using the primary yellow and blue tones, I made an independent new green tone. I mixed ultramarine blue and cadmium yellow light with three values of gray to make a green tint-tone-shade scale. This mix makes an excellent all-purpose neutral green. I call the three primary tones and the three secondary tones the Basic Tones. These tones and the Tint-Tone-Shade scales made from them comprise most of the tones used in every painting.

Basic Red:	Cadmium Red light: Parent color
	Yellow Ocher and Burnt Umber: Auxiliary colors
	Titanium White and Mars Black: Gray
Basic Yellow:	Cadmium Yellow light: Parent color.
	Yellow Ocher and Burnt Umber: Auxiliary colors.
	Titanium White and Mars Black: Gray
Basic Blue:	Prussian Blue: Parent color.
	Titanium White and Mars Black: Gray
Basic Green:	Cadmium Yellow Light and
	Ultramarine Blue: Parent colors
	Titanium White and Mars Black: Gray
Basic Orange:	Basic Red + Basic Yellow
Basic Violet:	Basic Red + Basic Blue

Modifying the tones is done by overpainting the Basic Tones with any color. For example, to intensify the yellow Basic Tone overpaint with its parent color, Cadmium Yellow Light. Cool the Basic green and create a more spectral green by overpainting with pure Viridian Green.

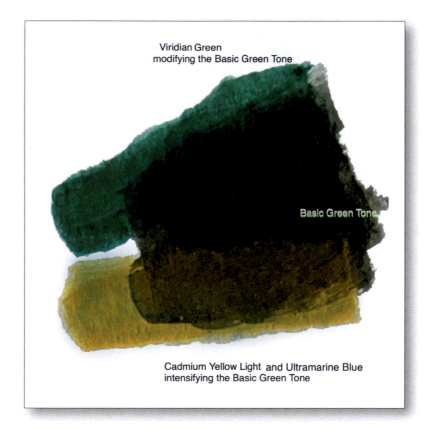

Viridian Green
modifying the Basic Green Tone

Basic Green Tone

Cadmium Yellow Light and Ultramarine Blue
intensifying the Basic Green Tone

APPENDIX II
Paint Application

There are many ways to apply the paint. The following samples demonstrate the ones I use frequently.

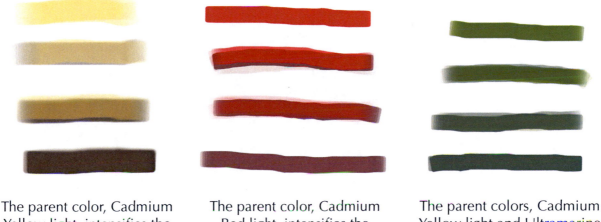

The parent color, Cadmium Yellow light, intensifies the Yellow Basic Tone.

The parent color, Cadmium Red light, intensifies the Basic Red Tone.

The parent colors, Cadmium Yellow light and Ultramarine Blue, intensify the basic Green Tone.

The illustration shows the progression of the yellow, red, and green tones from low intensity to maximum chroma. The first two bottom strips represent the underpainting made with Basic tones and containing a few slightly more saturated colors. The last two top strips represent overpainting with moderate to maximum chroma colors.

The layering process. In this sample, the translucent dark red tone at the bottom is over a dark opaque yellow tone. The middle tone red is translucent and over the dark red. The pure cadmium red color is transparent over the middle tone red and continues beyond the overlap emerging as the top layer of pure hue.

The layering process. From paint film opacity to translucency to transparency. From monochromatic to neutral color to pure color.

I use a brush in three ways: the Parallel Stroke, the Stipple Stroke, and the Circular Stroke.

The Parallel Stroke is exact and used to build subtle gradations.

The Stipple supplements the Parallel Stroke to create optical blending. Use it singularly to blend colors or invent a texture. Paint both with a sharp, pointed, round watercolor or soft flat brush.

The Circular Stroke is rubbing the paint in a circular direction. It is useful to create atmospheric effects and achieves a subtle physical blend of the color, but it lacks the precision of the other two strokes. Paint the circular stroke with a soft, worn round watercolor brush.

The Parallel Stroke The Stipple Stroke The Circular Stroke

Paint the Parallel and Stipple Strokes with a sharp, pointed, round watercolor or soft flat brush.

Paint the stroke with a soft, worn round watercolor brush.

To create various textures, use sgraffito tools and spatter brushes.

I use a toothbrush or Dremel circular brush to create textures with many small (granular) spots.

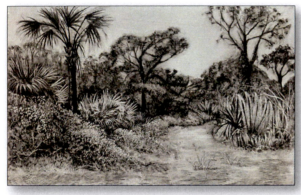

Scratch tools, spatter tools, and brush crate the monochromatic underdrawing.

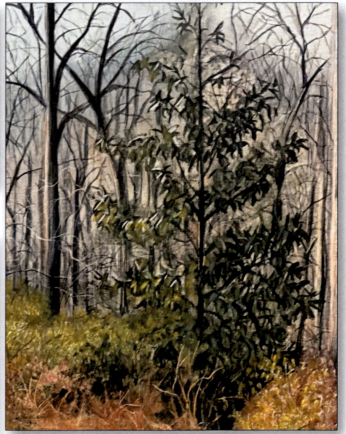

Parallel and Stipple Strokes working together make precise gradations. The smooth optical transitions are seamless.

Brushes, sgraffito tools, and spatter brushes create this painting.

Tooth brush

Dremel brush

The Homemade Scratch Tool with two points, pear carbide bur, and dental spatula are three examples of sgraffito tools.

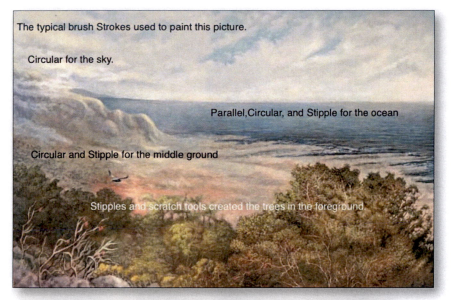

The typical brush Strokes used to paint this picture.

Circular for the sky.

Parallel,Circular, and Stipple for the ocean

Circular and Stipple for the middle ground

Stipples and scratch tools created the trees in the foreground.

All the brush strokes are active in this painting. The varnishing of the shadow selectively painted over the dark color increases the refractive index resulting in an intense dark shadow.

Unfinished painting. The monochromatic Dark Yellow underdrawing is complete. Circular Strokes apply the Basic Neutral Yellow Green.

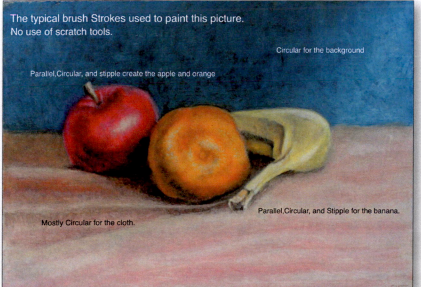

The typical brush Strokes used to paint this picture.
No use of scratch tools.

Circular for the background

Parallel,Circular, and stipple create the apple and orange

Parallel,Circular, and Stipple for the banana.

Mostly Circular for the cloth.

Traditional Brush Application

I prefer to use brushes to apply most of the paint instead of sponges, spraying, or other ways. My egg tempera technique to spread the color with a brush has a historical tradition. The **even-dry brush** method aims to produce a precise unified film of color that can rapidly allow another layer on top of it without lifting the prior. I describe the method as a **load-run-lift stroke.** Pick up paint with the brush. Squeeze the brush clean using a paper towel or rag. Unlike the conventional dry brush technique, the hairs of the brush are not splayed but kept even. It prevents lines from forming, resulting in a flat, even mark. Quickly drag the brush across a surface and rapidly lift the bush. The lift movement prevents the paint from uneven accumulation at the stroke's end edge.

Smooth Transitions

Creating imperceptible change from one value to another can be challenging. There's a similar difficulty of a color imperceptibly changing to another. Because egg tempera quick drying character physically attempting to blend is impractical. Achieve transitions by deliberately applying the paint to look like it's smoothly changing from one value or color to another. The color must first look evenly flat for the illusion of a smooth transition to work. There are several ways to do this. These include using sponges, paint rollers, airbrushing, and applying a final layer of grassa-surfactant, or oil. The following is a manner I've developed using a soft, round-flat watercolor or facial cosmetic brush that works for me.

1) Create a yolk-water-dense emulsion. The proportion of yolk to water is approximately four yolk to one part water. This emulsion gives the paint greater mass than if it had more water. The paint strokes are consequently more substantial.

2) Apply the paint thinly without diluting it with water in the even-dry brush method. I refer to it as thin-dense paint. This paint film will have a thicker body but quickly dry as water evaporates rapidly.

3) Apply the paint in parallel strokes. Don't overlap the strokes. Keep each one adjacent to the other. If there are gaps between strokes, fill in the gaps with quick dry stipple strokes using a small round watercolor brush. The look will be a flat, even color. It's important not to cross-hatch. It's best not to

follow the form, outlining it in one direction and another. The cumulative perception of these cross-hatched strokes depicts the change in spatial planes well but creates the appearance of surface texture, decreasing the softness needed for a seamless transition. Parallel strokes in one direction give the appearance of smooth atmospheric shapes. Consequently, the perceptions of different values and colors will be flat and even. It helps provide the shape formation for a smooth optical transition.

4) Build opacity by applying one smooth layer after another in the same stroke direction as the earlier layer. Do not assume that uneven strokes in a prior layer are correctable in the next.

5) To make smooth changes between values and colors, pre-mixing the values and colors is essential. Work primarily from dark to light. It's easier to create a lighter tone than a dark.

6) Take all the necessary time to achieve convincing, smooth surface transitions. Do not rush.

Make light, smooth transitions using thin-dense paint with an even-dry brush in load-run-lift-parallel strokes.

Make dark, smooth transitions using thin-dense paint with an even-dry brush in load-run-lift-parallel strokes.

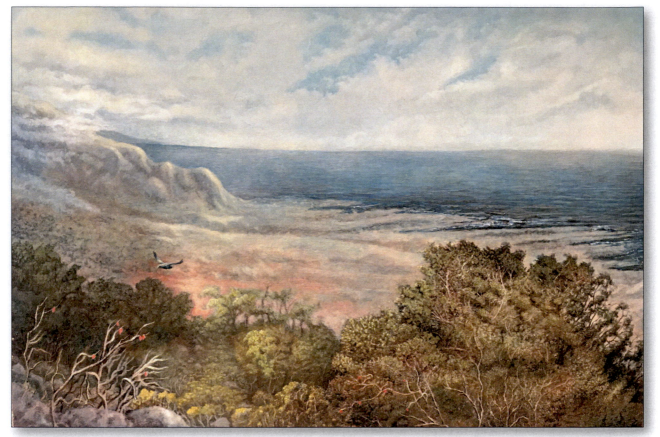

Fry George National Park, Chile. Studio painting. Egg Tempera on Hardboard primed with chalk ground, 10″ x 12″.

About the Artist

Ed Valdes is a native of New Jersey. He studied Art and Science at Rutgers University and Dental Medicine at Georgetown University in Washington, D.C. Making art and exploring nature has always been his passion.

Early Renaissance and the aesthetics of the 19th-century landscape painters influence his work. He has painted in Egg Tempera since 1994 and learned this medium from self-study, books, and experimentation.

After retiring from dentistry in 2016, he dedicated full time to painting. He currently lives in Florida.

His work shows in National and International Exhibitions and Private Collections in the U.S. and South America.

https://www.edvaldes.com

Endnotes

1 Casoli, Antonella. 2021. "Research on the Organic Binders in Archaeological Wall Paintings" Applied *Science*s 11, no. 19: 9179. https://doi.org/10.3390/app11199179

2 Ralph Mayer, The painters Craft (New York: Penguin Books, 1992), 137/141.

3 Wikipedia contributors, "Egg oil," Wikipedia, The Free Encyclopedia, https://en.wikipedia.org/w/index.php?title=Egg_oil&oldid=1088429372 (accessed August 4, 2023).

4 Kurt Wehlte, The Materials & Techniques of Painting (New York : Van Nostrand Reinhold Company, 1982), 172-174.

5 Mayer, The Painter's Craft, 17-22.

6 Darios Soares, Bruno. Apri 1 2021. " Technical Service and Development for Coatings at Oxiteno" Oxiteno. https://oxiteno.com/us/en/surfactants-paint-formulations/

7 Arists Network contributors, "Mixing Your Watercolor Medium," Artist Network, https://www.artistsnetwork.com/art-mediums/watercolor/mixing-your-watercolor-mediums/#:~:text=Gum Arabic is the binding water and some mild acid (access August 4, 2023).

8 Max Doerner, The Materials of the Artist and their use in painting (Orlando Florida : Harcourt Brace Jovanovich Publshers, 1977), 327-343.

9 Noelle L.W. Streeton, Perspectives on the painting Technique of Jan Van Eyck Beyond the Ghent Alterpiece (London : Archytype Publications Ltd, 2013), 9-29.

10 Daniel V. Thomson, Jr, The Practice of Egg Tempera Painting Material and Methods (New York: Dover Publications ,1962), 18-20.

11 Altoon Sultan, The Luminous Brush Painting with Egg Tempera (New York: Watson-Guptill Publications, 1999), 35-42

12 Fine Art Restoration contributors, July 27 2021. " Protecting paintings on panels: reducing risks and repairs," Fine Art Restoration CO https://fineart-restoration.co.uk/news/protecting-paintings-on-panel-reducing-risks-and-repairs/

13 Koo Shadler, Egg Tempera Painting A comprehensive Guide to Painting in Egg Tempera (Koo Shadler 2021), 258-261, Kindle.

14 Sultan, The Luminous Brush, 39.

15 Jonathan Stephenson, The Materials and Techniques of Painting (London: Thames and Hudson Ltd 1989), 108- 111.

16 Fiber Birren, Creative Color A dynamic approach for artist and designers (West Cester Pennsylvania: Shiffer Publishing Ltd), 27-29.

17 Jill Dunkerton, Susan Foister, Dillian Gordon, Nicholas Penny: Giotto to Durer Early Renaissance Painting in the National Gallery (London: National Gallery Publications, 1991), 193-204

18 McManus IC, Stöver K, Kim D. Arnheim's Gestalt theory of visual balance: Examining the compositional structure of art photographs and abstract images. Perception. 2011;2(6):615-47. doi: 10.1068/i0445aap. Epub 2011 Oct 19. PMID: 23145250; PMCID: PMC3485801.

19 Daniel V. Thompson, Jr, Cennino d' Andrea Cennini, The Craftsman's Handbook " Il Libro dell'Arte"(New York: Dover Publications 1954), 91-94.

20 Nikolic, Dusan. April 2022. "How did the Byzantines Influence the Italian Renaissance" The Collector https://www.thecollector.com/how-did-byzantine-influenced-italian-renaissance/

21 Nikolic, Dusan, How did the Byzantine Influence the Italian Renaissance.

22 Margaret Livingstone, Vision and Art The Biology of Seeing (New York: HNA Books, 2002), 46-66

23 Toney, Anthony. Painting and Drawing Discovering your Own Visual Language (Englewood Clifs, NJ Prenice -Hall Inc), 118-119.

24 H.G. Gombrich, Art and Illusion a study in the Psychology of Pictorial Representation (New Jersey : Princeton University Press, ninth printing 1989), 116- 287

25 Charles Bouleau, The painter's Secret Geometry a study of composition in art (New York: Dover Publishing 214), Chap.II, Kindle.

26 Gary B. Meisner,(The Golen Ratio, the divine beauty of mathematics (https://www. goldennumber.net: Race Point Publishing 2018), Introduction, Kindle.

27 Michel Jacobs, The Art of Composition (New York: Doubleday, Page & Company 1926), 32-42

28 Bouleau, The Painter's Secret Geometry, Chap. V, Kindle.

Index

Made in United States
North Haven, CT
02 January 2024

46946728R10091